MW00358937

BIRDS of
NEW YORK CITY

BIRDS of
NEW YORK CITY

CAL VORNBERGER

THE COUNTRYMAN PRESS
A division of W. W. Norton & Company
Independent Publishers Since 1923

Copyright © 2017 by Cal Vornberger

All rights reserved
Printed in China

For information about permission to reproduce selections from this book,
write to Permissions, The Countryman Press,
500 Fifth Avenue, New York, NY 10110

For information about special discounts for bulk purchases, please contact
W. W. Norton Special Sales at specialsales@wwnorton.com or 800-233-4830

Manufacturing by Toppan Leefung
Book design by Anna Reich
Production manager: Devon Zahn

Library of Congress Cataloging-in-Publication Data

Names: Vornberger, Cal.
Title: Birds of New York City / Cal Vornberger.
Description: New York, NY : The Countryman Press, A division of
W.W. Norton & Company, [2017] | Includes index.
Identifiers: LCCN 2016048015 | ISBN 9781581574074 (hardcover)
Subjects: LCSH: Birds—New York (State)—New York.
Classification: LCC QL684.N7 V677 2017 | DDC 598.09747/1—dc23 LC
record available at https://lccn.loc.gov/2016048015

The Countryman Press
www.countrymanpress.com

A division of W. W. Norton & Company
500 Fifth Avenue, New York, NY 10110
www.wwnorton.com

1 2 3 4 5 6 7 8 9 0

CONTENTS

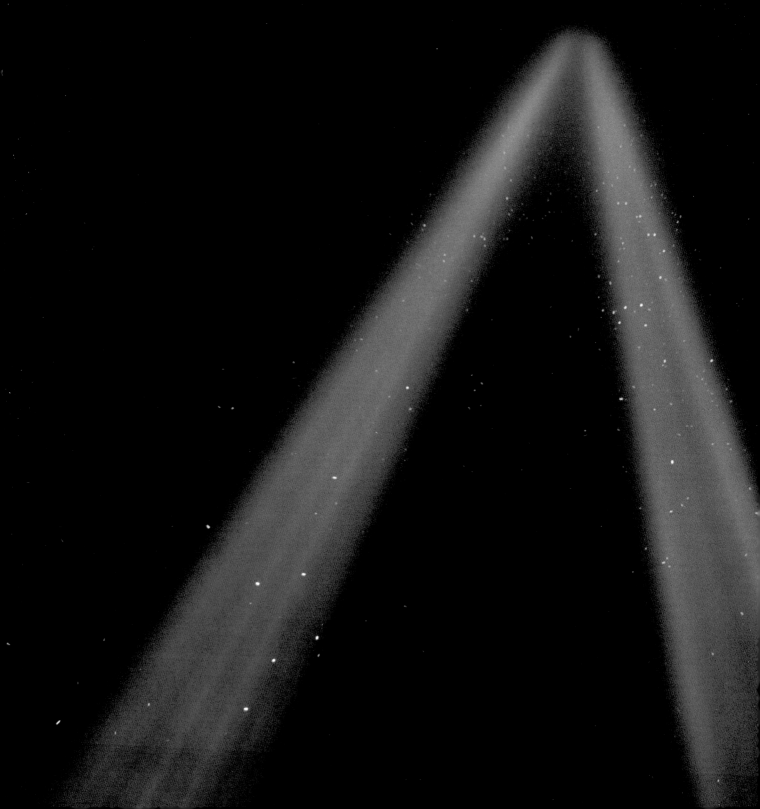

INTRODUCTION

Most people think of the pigeon as the quintessential New York City bird, but with more than 30,000 acres of wetlands, grasslands, and forests under protection, New York City provides food and shelter for hundreds of species while providing ample opportunities for bird watchers and wildlife photographers to observe and photograph them. In fact, birders generally find more than 200 different species during any given year, and there is some indication that the number can rise to nearly 300 during particularly abundant years.

Because New York City is located on the Atlantic Flyway, one of many imaginary paths in the sky that migrating birds follow during spring and fall migration, it is known as a "migrant magnet." As migrants head up the East Coast in spring, they stop to rest and feed in the city's parks and waterways before continuing their journey north to their breeding grounds. In late summer and fall, the reverse happens with the addition of shorebirds and raptors that traveled different paths north in the spring. For some migrants, the New York area is their final destination while there are other species that do not migrate at all and spend the entire year here.

Central Park was recognized by the National Audubon Society and the American Bird Conservancy as an "important bird area" in 1998 for its importance as a migration stopover. In addition, more than thirty species have been observed breeding in the park over the years. Other parks provide habitat for raptors and waterfowl, and Jamaica Bay Wildlife Refuge near Kennedy Airport (part of the Gateway National Recreation Area) is a popular stopover for migrating shorebirds in the fall and has its own population of nesting species including Yellow Warblers, Osprey, Brown Thrashers, and Willets.

The city's islands and beaches are breeding grounds for Great Egrets, Great Blue Heron, Black Skimmers, gulls, terns, and the federally protected Piping Plover, whose numbers have nosedived in recent years. In winter, Bald Eagles can be found feeding up and down the Hudson River, and just this year, Bald Eagles have been seen nesting on Staten Island and in Flushing Meadows-Corona Park in Queens. An effort to reintroduce Eastern Screech-Owls to Central Park has produced several successful breeding pairs whose offspring are featured in this book, and Hunter Island in the Bronx has been the home to a pair of Great Horned Owls for as long as anyone can remember.

A number of adaptive non-native species also make their home here. Monk Parakeets, a native of the Argentine pampas were a popular pet in the 1950s, and many escaped to breed in massive colonial nests in New York City and its suburbs. They can be found noisily tending to their nests at the entrance to Green-Wood Cemetery in Brooklyn. Also adapted to the local environment are European Starlings and House Sparrows, both originally European natives. And of course, the ubiquitous pigeon is not a native species but has spread rapidly across the Western Hemisphere during the late nineteenth and early twentieth centuries. Climate changes have also altered bird behavior with Mockingbirds, originally found much farther to the south, moving north to nest in this area. Several migrant species now stop their southern migration short of traditional areas farther south. Snow Geese are a prime example of this phenomenon called "backstopping." Flocks of

hundreds of thousands of Snow Geese can be found wintering in New Jersey, gleaning the remains of the fall harvest before heading north to their breeding grounds on the Hudson Bay.

Red-tailed Hawks, not usually known as city birds, have settled comfortably in New York City in the past twenty years—there are now more than twenty breeding pairs within the city limits, including "Pale Male," the famous hawk who has nested on the façade of a building on Fifth Avenue since 1992. Usually, a breeding pair would defend a territory of at least five square miles, but with the abundance of food in the city, that no longer holds true.

New York City can also be a dangerous place for migrants and resident birds alike. Every year thousands of songbirds are killed by feral cats, and even more die during spring and fall migration when they slam into glass-clad skyscrapers during their migration at night. Light pollution also plays a part in the death of migrating birds as bright lights on buildings confuse them and cause them to circle buildings endlessly until they are exhausted. In 2015, as part of the Audubon "Lights Out" initiative, Governor Andrew Cuomo ordered state-owned buildings to turn their lights out from 11 p.m. until dawn, from April 15 through May 31, to aid migrating birds. Other non-state-owned buildings in Manhattan also participate in the program. Perhaps the most telling example of this is the "Tribute in Light," which illuminates the night sky every September 11th. These bright searchlights in lower Manhattan, near the site of the Twin Towers, attract thousands of migrants that are trapped endlessly circling the shafts of light wasting energy needed to continue their migration (see photo on page 6). At the behest of New York Audubon, the lights are now turned off for twenty minutes when too many birds have gathered, allowing them to continue their migration. The lights are then turned back on until more birds congregate. This usually happens three or four times during the night until 5 a.m. on September 12th, when the lights are turned off for good until the next year.

Since I began photographing birds in New York City in 2000, I have

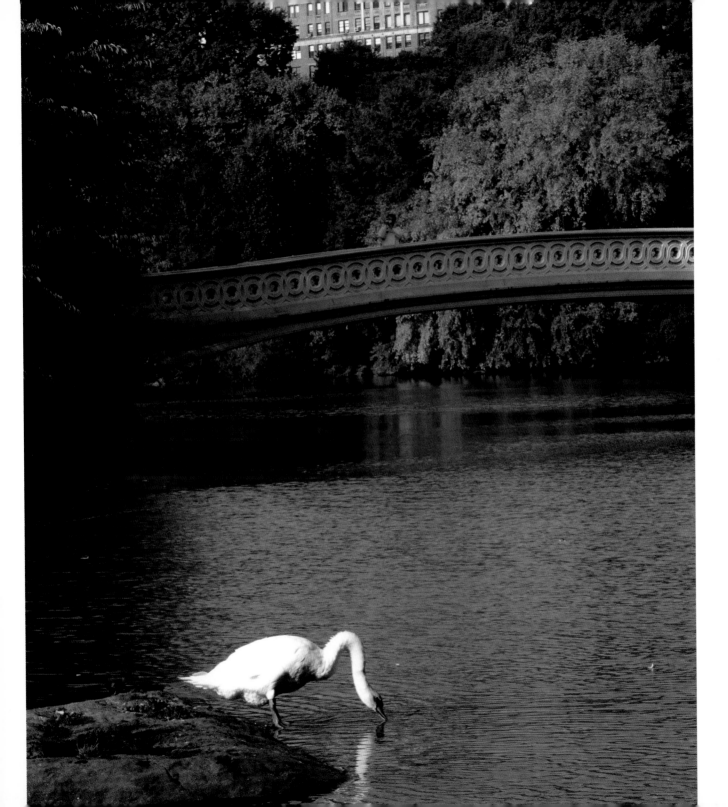

encountered more than 250 different species, including vagrants that are not native to the area but still got photographed and added to my list. With the warming of the planet, we will see more vagrants appearing, moving northward from the south and eastward from the west in search of food and new breeding territory. Future climate change will have a profound effect on bird populations both good and bad. No doubt many species will be able to adapt, but others may not be so fortunate. Only time will tell.

SPRING

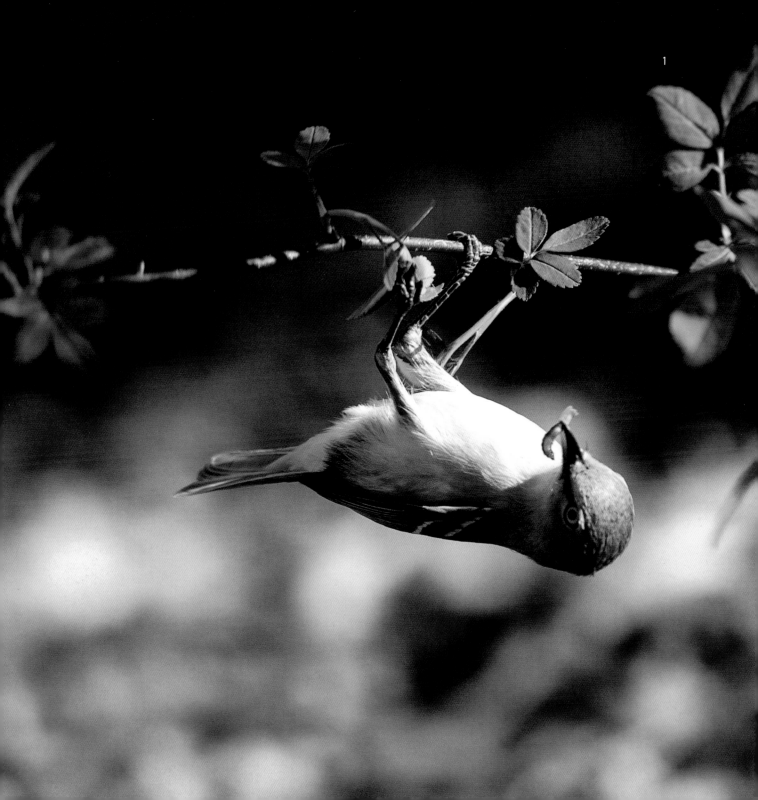

White-eyed Vireo ∎1

This small songbird has olive uppers and yellow sides, as well as two white wing bars. As the name implies, its large eyes are white—and surrounded by yellow "spectacles." Males and females have similar coloration. Lower New York State is at the edge of its northern breeding territory, although it seems to be making a comeback farther north. Their range extends west to the Mississippi and south to the Gulf of Mexico. Found year-round in Florida and other Gulf Coast states while most winter in the Yucatan and the Caribbean. In this photo, a White-eyed Vireo is hanging upside-down from a branch while it plucks an insect from the underside of a leaf.

Palm Warbler ∎2

Although the Palm Warbler winters in the southeastern United States, it is rarely seen in palm trees. It is a bird that prefers thickets and open fields, where it feeds on insects, berries, and other vegetable matter. The bright rufous cap of the male and its constantly bobbing tail make it easy to identify. It is one of the earlier migrants to pass through the New York area on its way to its breeding grounds in Canada where it begins nesting in early May. It's likely that most Palm Warblers raise two broods per year before returning to their wintering grounds in the late fall. Fall plumage is much duller, and the male may lose the rufous cap entirely. This male was photographed in a crabapple tree in the Ramble in Central Park in late April.

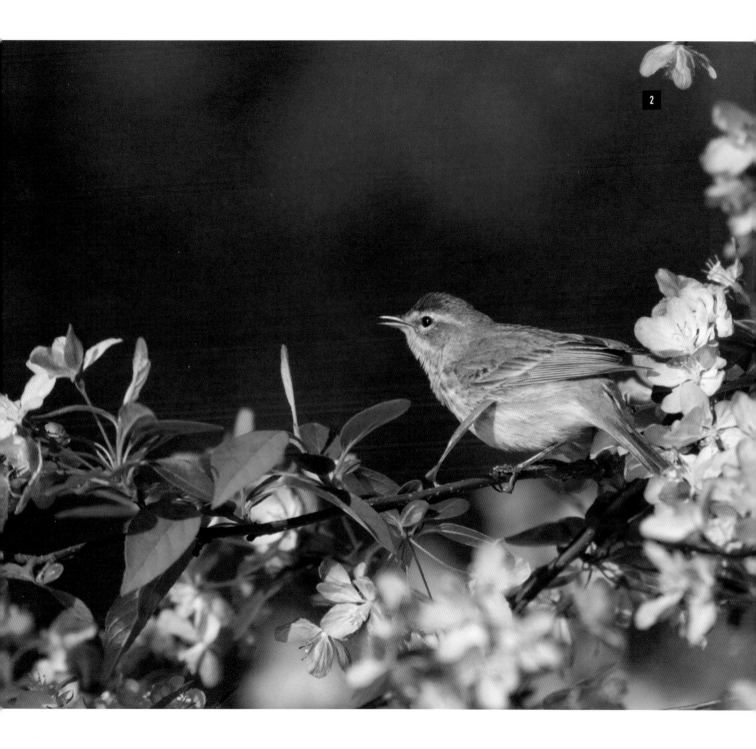

Orchard Oriole 1

Orchard Orioles feed on insects and fruit and nectar. This first-year male is feeding on the nectar of Carolina silverbell flowers in Central Park. This first-year male has yet to develop the distinctive coloration of the adult male, but he does have the black around the bill and throat that differentiates him from the female, that is the same color but has no black on her face. Orchard Orioles are infrequent visitors to local green spaces, although they breed throughout the eastern and southern United States. They winter in the Yucatan Peninsula as well as central and northern South America.

Ruby-crowned Kinglet 2

This tiny bird usually keeps its ruby crown hidden and only displays it during mating or when it's agitated. The Ruby-crowned Kinglet breeds in the boreal forests of northern Canada and Alaska and winters in the southern United States and Mexico. It can be found in the New York area during early in spring and late in the fall as it passes through on its way south. Its movement frenetic, the Ruby-crowned Kinglet flicks its wings as it moves from branch to branch searching for insects. This photo was taken early one morning at Belvedere Castle in Central Park in late April.

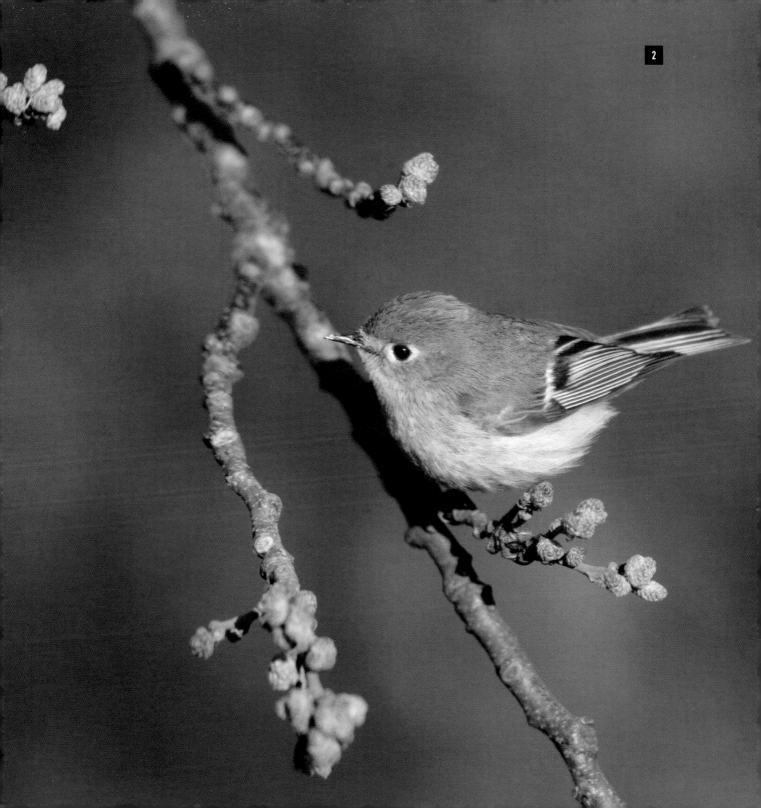

Summer Tanager

The Summer Tanager is an infrequent visitor to the New York City area, preferring a warmer habitat in the South and Southwest. The female is a mustard yellow, and both male and female have large blunt beaks with chunky bodies. Summer Tanagers are insectivores that feed on bees and wasps while somehow avoiding being stung. They will also feed on small fruit and berries. The birds migrate to southern Mexico and South America each winter and return to their breeding grounds in the southwest and southern United States in spring. Although originally classified in the tanager family, DNA studies have placed the birds within the Cardinal family. This male was seen over several weeks during the spring in the north end of Central Park near the Blockhouse, an old stone fort dating back to the War of 1812. Although this one did not sing, his bright color made him easy to spot. Expect to see more Summer Tanagers in the New York City area as the climate warms.

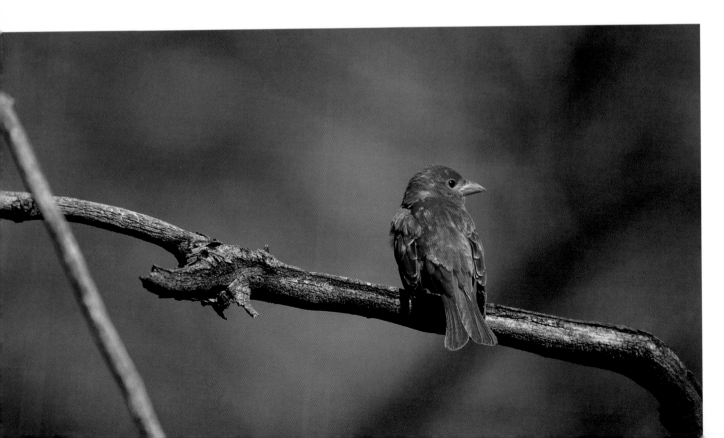

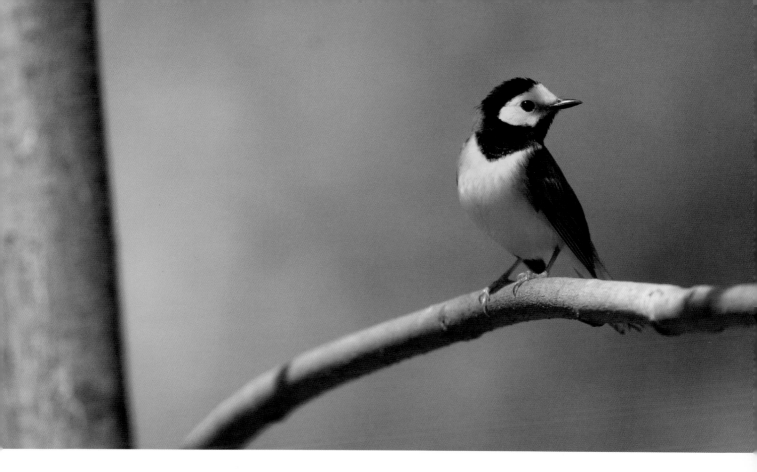

Hooded Warbler

Hooded Warblers breed in the eastern and southern United States and winter in the Caribbean, Yucatan, and Central America. The male is bright yellow on his head and belly, with a black "hood" that extends from below the bill and around the neck, covering almost half of the head. Wings and back are olive-green. Females have an olive-green cap that only covers about half their head. Hooded Warblers are insectivores, feeding close to the ground in the leafy undergrowth. They also nest close to the ground and are subject to parasitism by cowbirds. This photo was taken in the Loch in the north end of Central Park in late April.

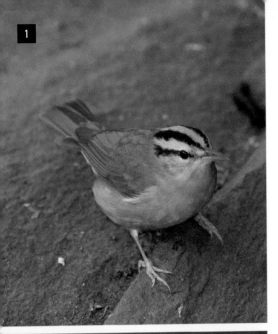

Worm-eating Warbler 1

A small warbler, buff-colored on the breast and head with a black eye stripe and two stripes on the top of the head. Although it is a ground feeder and forages in the leaf litter, it is not known to eat earthworms. There is no difference in coloration between males and females. They nest throughout the eastern and central United States and were once an abundant breeder in Westchester County. Because they are ground nesters, increased deer populations in the New York metropolitan area have been detrimental to the local population of breeding Worm-eating Warblers and they no longer nest in the area.

Yellow Warbler 2

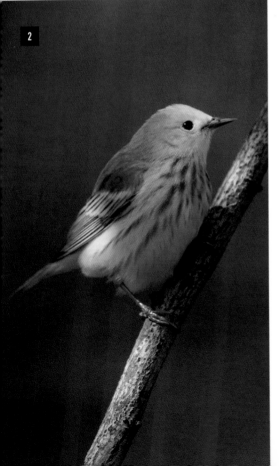

The Yellow Warbler is a very common warbler in our area and throughout the United States and Canada. The Yellow Warbler is known to breed at Jamaica Bay, Orchard Beach, and many other sites around the tristate area. This smallish bright yellow warbler has reddish stripes on its chest and large black eyes. Yellow Warblers forage in low shrubs and trees and move around constantly as they search for insects. They winter in Central and South America, mostly in mangrove swamps, and their breeding territory extends to northern Canada and Alaska.

Ring-necked Pheasant 3

Ring-necked Pheasants are not native to North America but were introduced into the country from Asia in the late 1800s. They quickly became a popular game bird and spread across most of the United States and western Canada. The male's long slender tail, iridescent head, and bright

red face make it easy to spot and identify. The female is drab compared to the male but still heavily patterned with a distinctive slender tail. The white ring around the male's neck gives the species its descriptive name. They are large birds with long necks and legs and can quickly burst into flight from a standstill when spooked. They are only occasionally found in New York City parks, usually after having flown across the Hudson from New Jersey, where they are most commonly found in open fields and farmland. This beautiful male was found wandering through Central Park's North Woods. Ring-necked Pheasants have also been spotted in Riverside and Van Cortland Parks, and I once observed a female and family running through the low brush in an empty lot in Arverne, Far Rockaway.

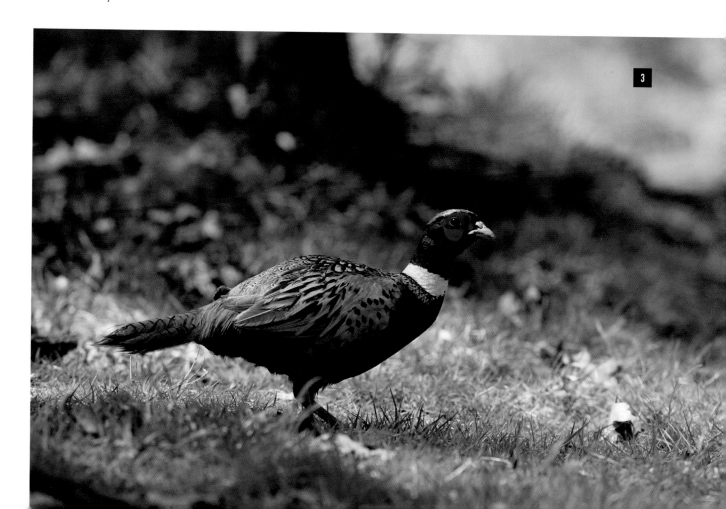

3

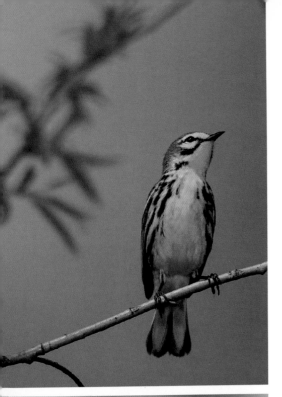

Prairie Warbler

The New York metropolitan area is located on what is known as the "Atlantic Flyway," an imaginary road in the sky followed by millions of migrating birds during fall and spring as they move to and from their wintering grounds in the Caribbean and Central and South America. The Atlantic Flyway deposits a startling array of migrating warblers in New York City's parks and green areas, and one of the first to arrive on its way north in the spring is the Prairie Warbler. The male Prairie Warbler's breeding plumage is bright yellow with black stripes down the side and back. The female is a dull olive with dark streaks on her sides. Prairie Warbler numbers are declining as habitat is lost. It is known to nest in the Northeast—not in open prairies, but in second-growth scrub and areas of new growth after fires. This male was feeding in the Ramble in Central Park in early April.

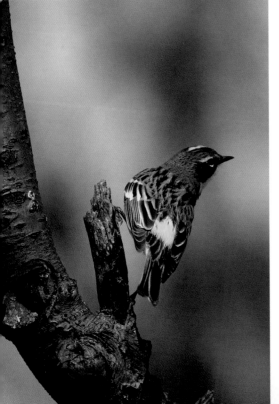

Yellow-rumped Warbler

Yellow-rumped Warblers are among the most numerous warblers to flood the New York City area in spring. With their striking black-and-gray feathers and bright yellow patches on the rump, wings, and throat, the males are a common sight throughout the area. During breeding season, they can be found north of New York City and as far away as Hudson Bay and Alaska. Yellow-rumped Warblers winter in the southern United States and Mexico, but they are one of the few warblers that can also overwinter in the Northeast, where they can be found in coastal areas subsisting on bayberries and other fruits and nuts. This shot was taken in early spring in the Ravine in Central Park, but I have also photographed Yellow-rumped Warblers at Jamaica Bay in the fall and winter.

Red-tailed Hawks

These are two offspring of that famous pair of Red-tailed Hawks, Pale Male and Lola, in a nest on a building at 927 Fifth Avenue in Manhattan. This photo was taken from the next building over and shows the two young birds nearly ready to fledge. Red-tailed Hawks are among the most common hawks in North America and are typically year-round residents. They are increasingly found in urban areas. In addition to this nest, there is another active nest at St. John the Divine on 110th Street on the Upper West Side. Red-tailed Hawks in the city feed mostly on rats, mice, and squirrels, finding an abundant supply on the city's streets and in its parks and green areas. Pale Male's offspring usually fledge during the second or third week in June, depending on when the eggs were laid. It is estimated that Pale Male is at least 26 years old and has outlived several mates. He gets his name from his pale coloration.

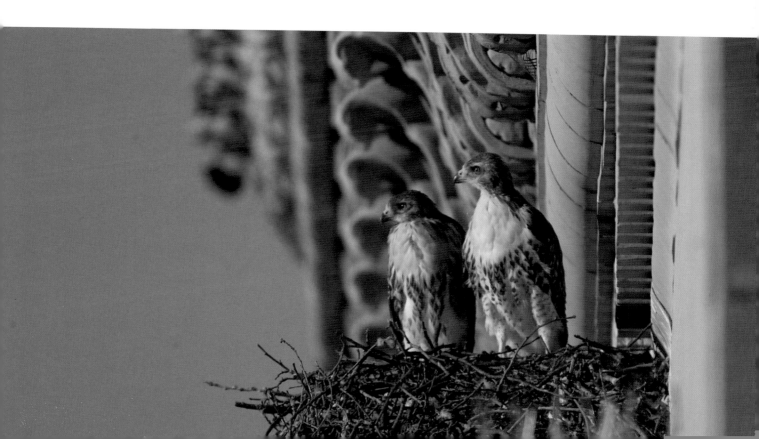

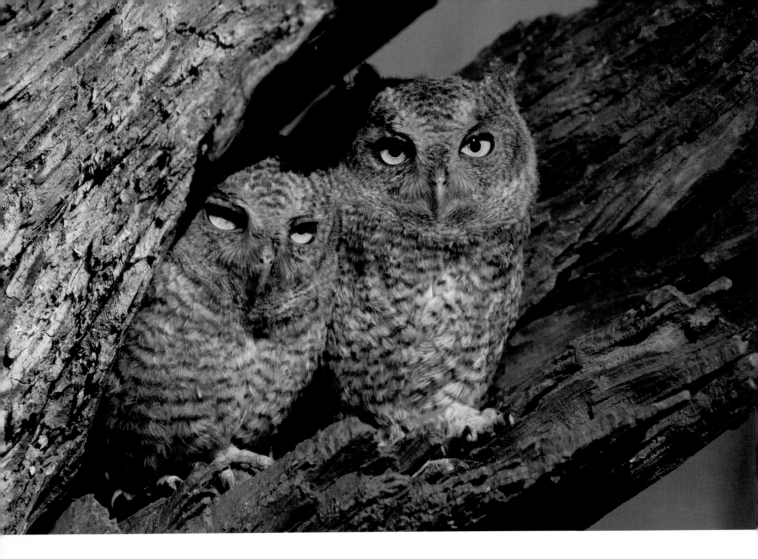

Eastern Screech-Owl fledglings

These young Eastern Screech-Owl fledglings were discovered in a tree cavity in the North Woods of Central Park. They had yet to fledge and looked out from their nest with unbridled curiosity. Screech-owls are short, stocky birds found year-round throughout the eastern and central United States and can be either gray or reddish in coloration. They

are nocturnal but can sometimes be seen during the day in the entrance to their home, usually in a tree cavity. The Eastern Screech-Owl has an interesting history in Central Park. Up until the mid-1950s, screech-owls were observed nesting in Central Park, but after that time, not a single Eastern Screech-Owl was observed. This just happens to coincide with when the park was opened up to vehicular traffic. A couple of years ago, I watched an Eastern Screech-Owl leave its nest cavity and fly right into the path of an oncoming car on Central Park's West Drive. The owl was struck by the car and momentarily stunned, but after a few seconds of recovery, it flew off into the night. As of the date of publication of this book, the original thirty-eight screech-owls that were introduced into the park now number no more than five pairs and possibly less. There have been no sightings of these owls in Central Park in the past several years but as they are nocturnal and secretive, they may still be around.

Northern Parula

The Northern Parula is a small warbler that exists in two distinct breeding populations, one in the southern United States, where they nest in Spanish moss, and the other farther north where they build their nests from lichen. The male is distinguished by a blue-gray head and back and a yellow chin and chest broken by a dark reddish band across it. Southern breeders return by early March and are already nesting as their northern counterparts move through their area from the Yucatan Peninsula, Carribbean, and Central America. Northern Parula are found year-round in southern Florida. This shot shows the male in a typical pose hanging from the branch of a bald cypress in Central Park.

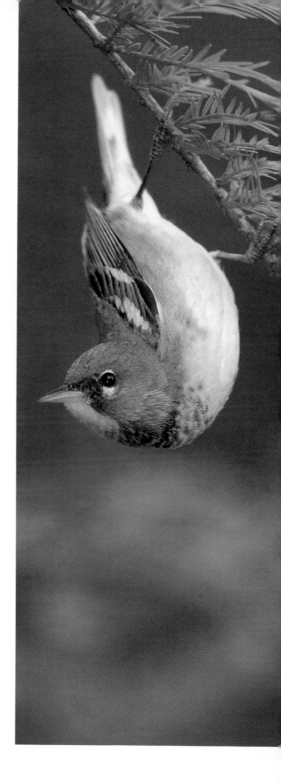

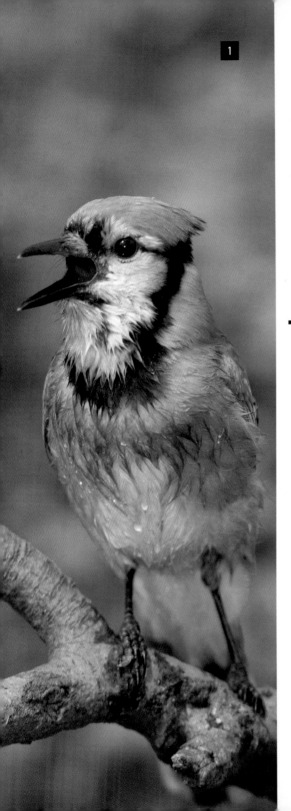

Blue Jay 1

This loud, colorful bird is found in most states east of the Rockies and in southern Canada. Most remain within this range year-round, although some northern birds will migrate south in the fall. They are common visitors to feeders in city parks and suburban backyards. Males and females have the same coloration, which runs from lavender on the head through cyan on the tail feathers. It has a crest on the top of its head that is raised when the bird is agitated. They are great mimics. This Jay in the Ramble in Central Park was mimicking a Red-tailed Hawk when I spotted and photographed it.

Cerulean Warbler 2

A rare visitor to the New York metropolitan area, this male Cerulean was found in the trees of West 89th Street just off Central Park. It was observed flitting from tree to tree and feeding on insects during the first week in May. While some Ceruleans nest farther upstate in the Bear Mountain area, they don't usually follow the Atlantic Flyway northward from their wintering grounds in the mountains of South America. Instead, they tend to follow the Mississippi and then branch eastward. Cerulean populations seem to be declining because of habitat destruction in their wintering grounds as well as increasing cowbird parasitism. The drab female contrasts with the brightly colored male, but both male and female have thin pointed bills and wing bars.

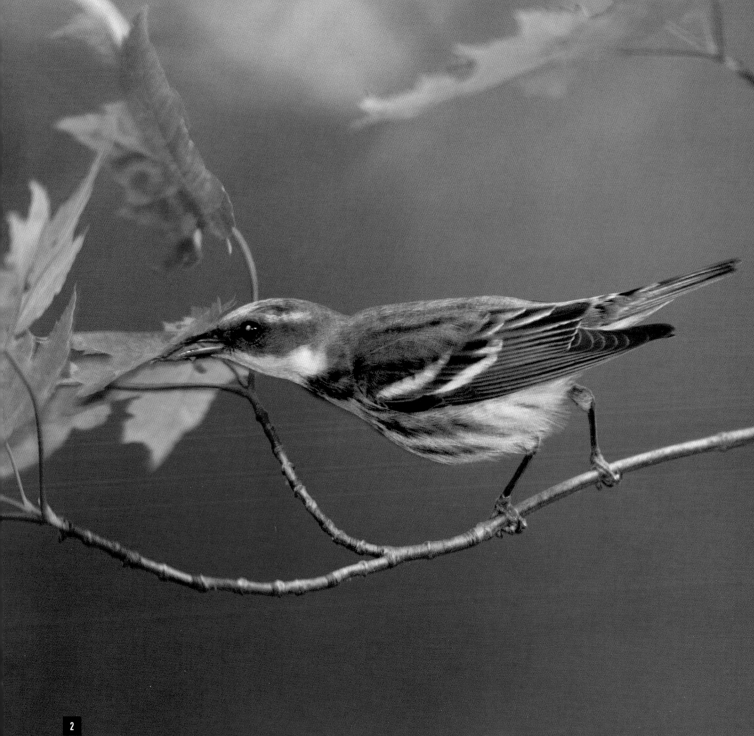

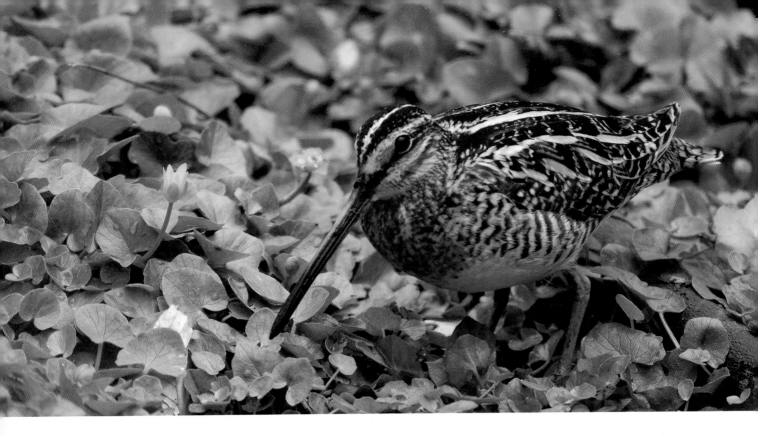

Wilson's Snipe

These long-billed shorebirds are among the most common sandpipers in North America. Although solitary and hard to spot, they inhabit most marshlands and travel up and down the East Coast on their way to and from breeding grounds in Canada and northern New England. They winter in the southern United States but have been found in the Caribbean and South America. They have very long beaks (about twice the length of their heads) and short legs. They probe for insects in soft soil with these sensitive beaks as their heads bob up and down, not unlike a pumping oil well. Their intricate patchwork of earthy colors makes them difficult to see. The key to finding them (and their cousin, the American Woodcock) is to stand in one spot and watch for their characteristic up-and-down movement.

Lincoln's Sparrow

An uncommon visitor to the area, the Lincoln's Sparrow is much more prevalent in the West, where it prefers higher elevations. It breeds across Canada and up through Alaska. It passes through this area in spring, but it is a skulky bird that stays close to the ground and is hard to spot among the leaf litter. The best places to find it are near watering holes when it comes down to drink on warm spring days. It is a handsome bird, if a bit drab, and can be identified by the fine streaks on its buffy breast. There is no difference between the males and females of the species. John Jay Audubon discovered this bird on an expedition to Labrador and named it for Tom Lincoln, a member of the exhibition. This bird was photographed in the Loch in the north end of Central Park.

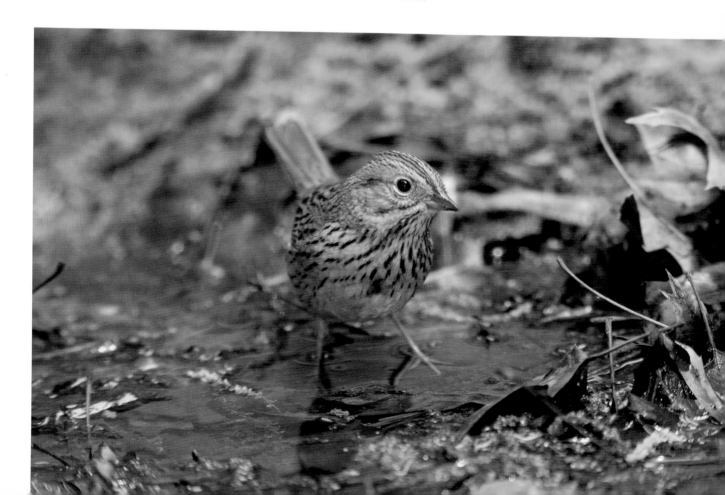

Sora

Although the Sora is one of the most abundant rails in North America, it is secretive and not often seen. The Sora has a slate-gray body with a black mask and yellow beak. This Sora was found in a stand of cattails at the south end of Prospect Park Lake in Brooklyn. It took three days of stalking the bird before I got a decent shot. Soras prefer freshwater marshland but will move into saltwater marshes in the winter. Their breeding range includes most of the United States and Canada, and they winter in Mexico, Central and South America, and the Caribbean. They are also found in states bordering the Gulf of Mexico in winter.

Black-throated Green Warbler

This male Black-throated Green Warbler is warning another male to keep its distance on a perch above Tanner's Spring in Central Park. The male has a distinctive yellow head with a black throat and an olive back. The male has bold black streaks on its sides and two distinct white wing bars. The female is similar to the male, but the chin and throat are a paler yellow. It is a very commonly seen warbler during migration and nests in New York State as well as up through eastern and central Canada. It winters in Mexico, the Caribbean, and northern South America and is rarely found west of the Rockies.

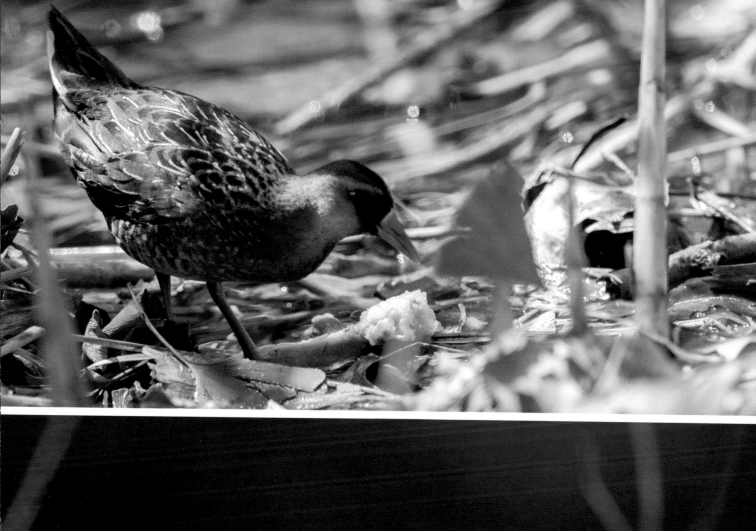
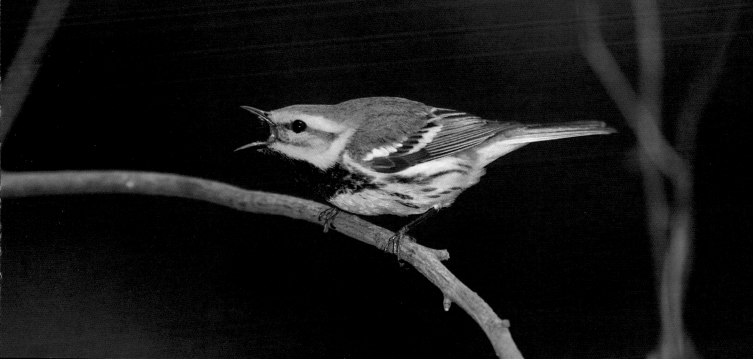

American Redstart

The male American Redstart is mostly jet black with orange sides and orange patches on its wings and tail. Undersides are white. Females also have white undersides, but their back and head are gray with patches of yellow on the tail, wings, and sides. Constantly in motion, the Redstart flicks its tail and wings while feeding to flush insects from branches so they can be pursued and eaten. American Redstarts winter in Central and South America and breed in the southeastern and central United States as well as up through New England throughout most of Canada. The male's jet-black top, along with his white undersides, makes him incredibly difficult to photograph.

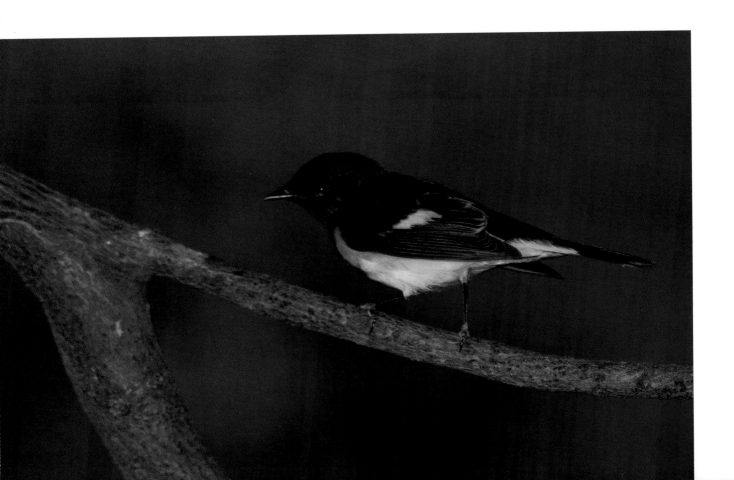

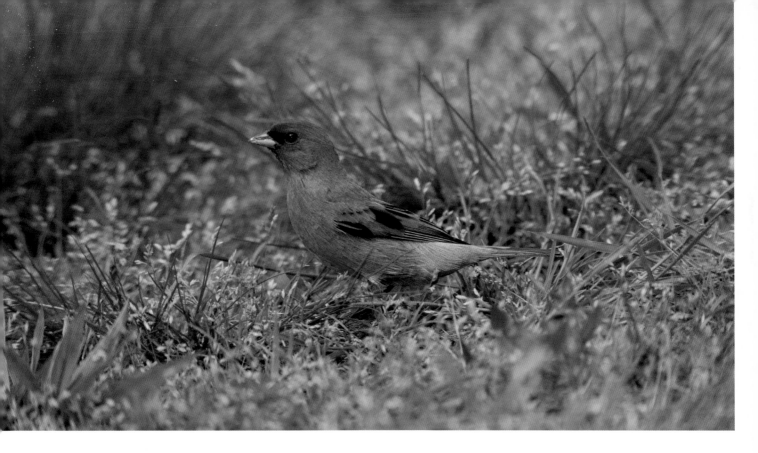

Indigo Bunting

Indigo Bunting are about the size of a small sparrow. The adult male in his breeding plumage has a cerulean blue body, with only the head being a true indigo. In this photo, shot in Central Park, the bird appears to be only just coming into its breeding plumage, as there are still patches of brown on its neck and side. The female is a plain brown, better to camouflage her while she sits on the nest. The male may have more than one mate on his breeding ground, and the female may produce two broods a year. The Indigo Bunting ranges from northern Florida through southern Canada during the breeding season and breeds locally in the tristate area. There are several breeding populations near the United States Military Academy at West Point in Orange County.

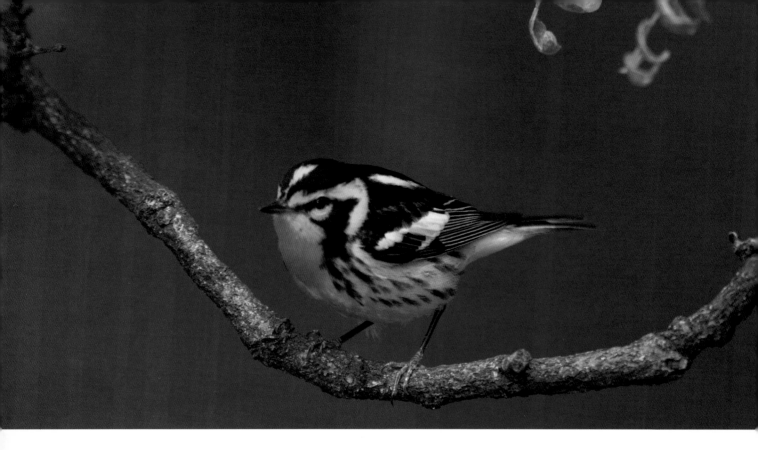

Blackburnian Warbler

The unique flame-orange-and-black coloration of the Blackburnian Warbler is like no other North American bird. The Blackburnian Warbler breeds in the northern forests of the United States and Canada and winters in South America, particularly in the northern Andes. The female has similar (albeit slightly less intense) coloration as the male and tends toward yellow and gray, lacking the bright orange of the male seen here. This bird is an insectivore and usually feeds in the tops of trees as it moves through the area, although it does come down to drink and bathe, usually in the early evening on warm spring days. This male Blackburnian was perched low on a branch above a small spring in Central Park.

Rose-breasted Grosbeak

The Rose-breasted Grosbeak is a large songbird that is a member of the Cardinal family. The adult male in breeding plumage has a black head, back, and tail and features a bright rose-colored patch on his chest. The undersides and rump are white, and the combined effect is striking. The female is yellowish-brown and heavily striped, with no hint of red. Both have a strong beak useful for cracking seeds, but they also feed on insects and small fruits and berries. The word "grosbeak" is from Old French, where "gros" means large. The Rose-breasted Grosbeak winters in the Yucatan, the Caribbean, Mexico, and Central and South America; it breeds in the deciduous forests of the eastern and central United States and Canada. This beautiful male was photographed in the North Woods of Central Park.

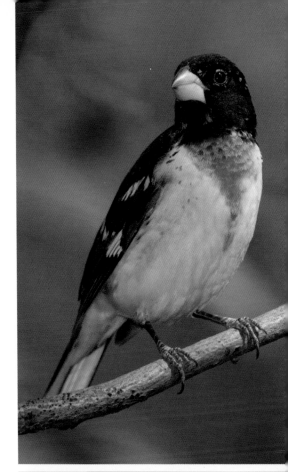

Baltimore Oriole

Baltimore Orioles nest all over the five boroughs, including in many New York City parks. There are at least two that nest every year in Central Park. They are easy to spot because the male has a striking orange body with a black head that mimics the heraldic colors of the seven-teeth-century Lord Baltimore. The female is bright orange with a dark-ish head. Baltimore Orioles are members of the blackbird family and share the same long, thick bill with the rest of that group. They are smaller than a robin, with long legs and a thick neck. They breed in the eastern and central United States as well as in southern Canada and winter in Florida and Central and South America.

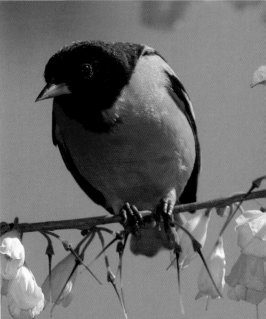

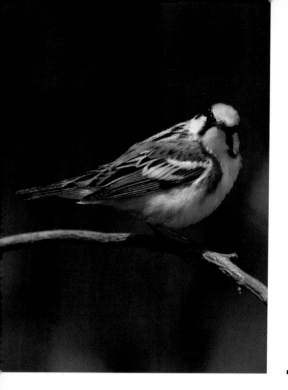

Chestnut-sided Warbler

While the clearing of forests in the Northeast and Canada has been detrimental to some species, the Chestnut-sided Warbler prefers the kind of bushy habitat that the cutting of forests creates. The bird breeds throughout New York State and farther north and east; its typical breeding areas are similar to the scrub created by the high-tension towers that cut through Sterling Forest in Sullivan County. Chestnut-sided Warblers pass through the New York metropolitan area in spring on their way north from wintering grounds in Central America and the Caribbean. The male has a distinct acid-yellow cap with black "sideburns" and chestnut patches on its sides. The female is a more subdued version of the male, with a yellow cap and less extensive chestnut streaks on its sides. This photo was taken at Tanner's Springs in Central Park.

Eastern Whip-poor-will

The Eastern Whip-poor-will is named after its haunting song that sounds like it's singing, "Whip poor will." Often heard but not seen, the Whip-poor-will is nocturnal, feeding on flying insects from dusk until dawn. Adults are very mottled with black, gray, and brown plumage on their upper bodies and wings. Males have a white patch below their throats. Whip-poor-wills winter in Florida and farther west, around the rim of the Gulf of Mexico into eastern Mexico and Central America. At a Yankees' night game early in the baseball season, I have observed Eastern Whip-poor-wills chasing flying insects through the lights of Yankee Stadium.

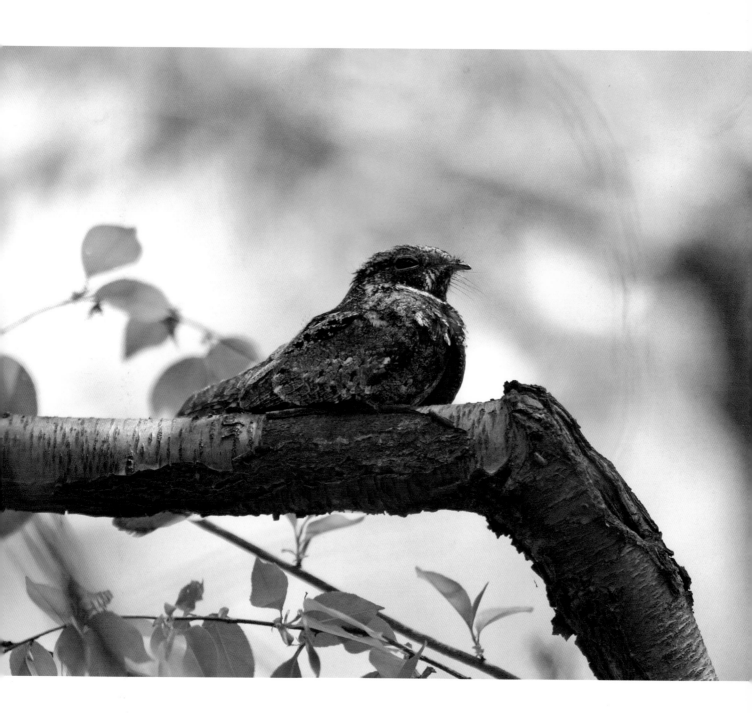

Cape May Warbler

The Cape May Warbler feeds on the spruce budworm in the boreal forests of Canada and the United States. On its wintering ground in the Caribbean, its uniquely shaped tongue allows it to feed on nectar. Although the Cape May Warbler was first observed in the Cape May area by colonial ornithologist George Ord, it was not seen there for another 100 years. Nor is it a frequent visitor to that area during migration. The male Cape May Warbler is distinguished by a bright yellow neck and chin and a yellow breast with black stripes. He has a darkish cap and white wing bars. The female has a grayish-yellow head and back and has yellow on the sides of her neck, throat, and breast, with less pronounced gray stripes on her breast. This singing male was seen in the Ramble in Central Park.

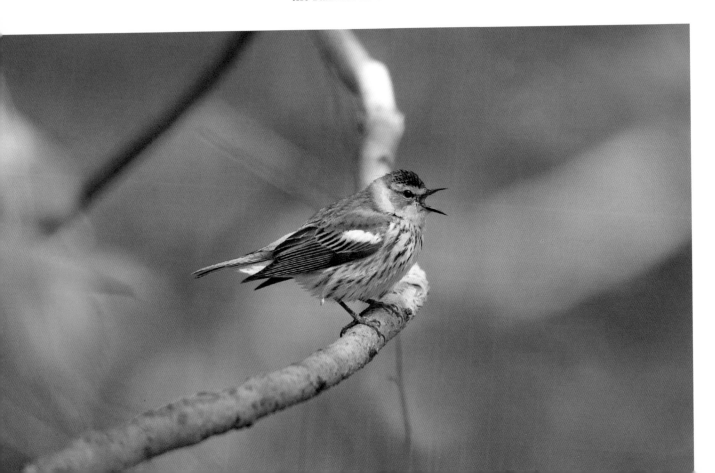

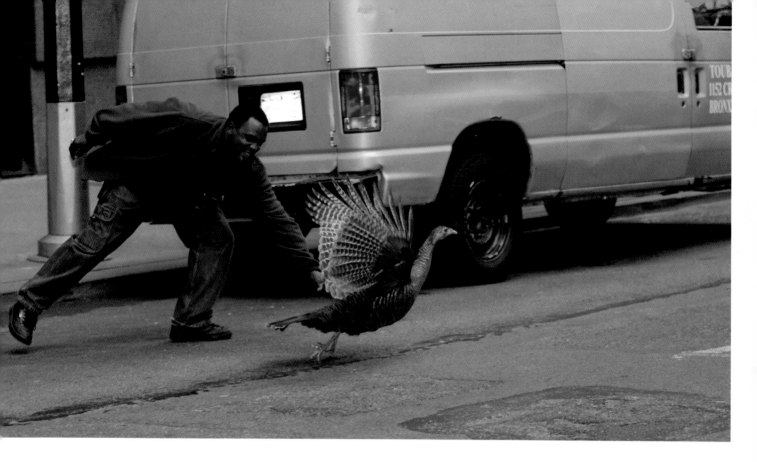

Wild Turkey

This female Wild Turkey was named Zelda and lived in Battery Park from around the middle of 2003 until her death in 2012. She would build nests and lay unfertilized eggs and roam the neighborhood, presumably looking for a mate. One spring morning, I found her wandering up Broadway in heavy traffic. In this shot a man is trying to catch her, but she always remained elusive. She survived Superstorm Sandy but was struck and killed by a truck in 2014. There are flocks of Wild Turkeys in Van Cortland Park and across the river in New Jersey, but few ever make it to Manhattan, let alone last more than nine years. The average lifespan of a Wild Turkey is six years.

Kentucky Warbler

Kentucky Warblers are very rarely seen as far north as the New York metropolitan area, preferring the deciduous forests of the southeastern and central United States. The bird is a ground feeder, preferring deep wooded ravines and areas near streams and swamplands. The male has an olive back and yellow underparts, with black sideburns down the face and throat. The Kentucky Warbler winters in the Caribbean and the Yucatan, Central America, and northern South America. This bird was seen for almost a week in and around Strawberry Fields in Central Park, feeding in the grassy areas and seemingly impervious to all the passing people.

American Robin

The pundit who opined that "the early bird catches the worm" must have had the American Robin in mind. Robins are not long-distance migrants, so when people in the northern United States and southern Canada see the first robin in spring, it likely hasn't migrated very far from its wintering grounds in the mid-Atlantic states. Robins breed throughout the United States (including Alaska) and Canada. While often seen in urban areas, these orange-breasted birds are equally at home in the wild and nest in Canadian boreal forests, mountains, and the Alaskan wilderness. These robins built their nest in a traffic light on East Drive in Central Park near 102nd Street. They successfully raised four young but never nested in the light again.

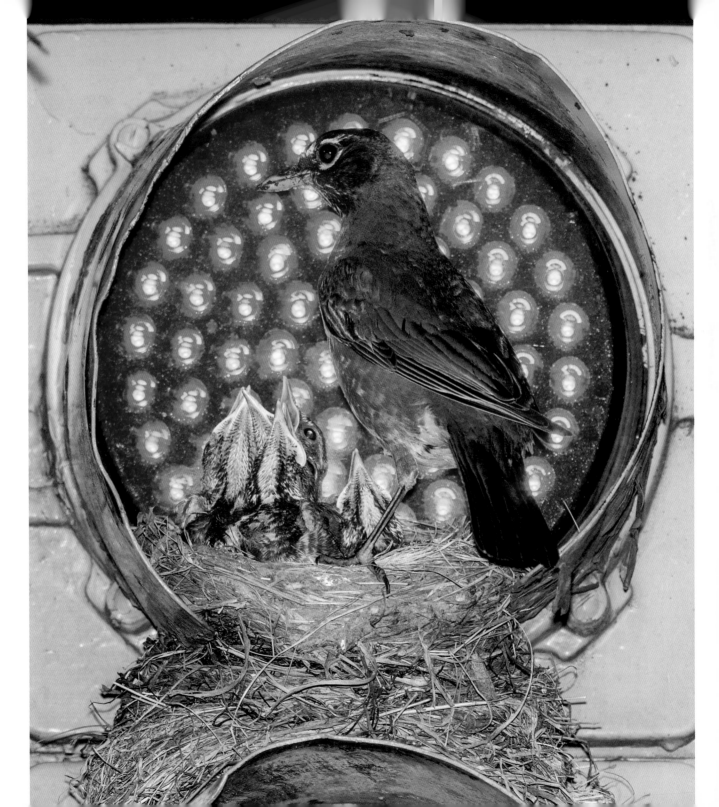

Prothonotary Warbler

The male Prothonotary Warbler is large for a warbler, with an intense yellow-orange head and yellow breast. The male has an olive back with black eyes and gray wings. He also has a relatively long, pointed beak and a white belly and undertail. The female looks similar to the male, but her crown is a dull greenish-yellow color. In the summer, they prefer breeding in swamps and low-lying areas from the Gulf through Maryland and southern New Jersey. They seem to be extending their range northward, as there have been increased reports of Prothonotary Warblers in the New York City area. They spend winters on the east coast of Mexico, the Yucatan, and Central America.

Bay-breasted Warbler

In the spring, the male Bay-breasted Warbler is striking with his chestnut cap, flanks, and throat, set off nicely by his black face and gray back. He also has dark eyes and black legs and two wide white wing bars. When he passes through this same area in fall to return to his wintering grounds in the Caribbean and South America, the male Bay-breasted Warbler has undergone a striking transformation, becoming olive green with a yellowish breast. The female is a toned-down version of the male. These birds nest in the coniferous forests of Canada and their population growth is directly dependent on the spruce budworm population. In years when there are more budworms, there are more offspring.

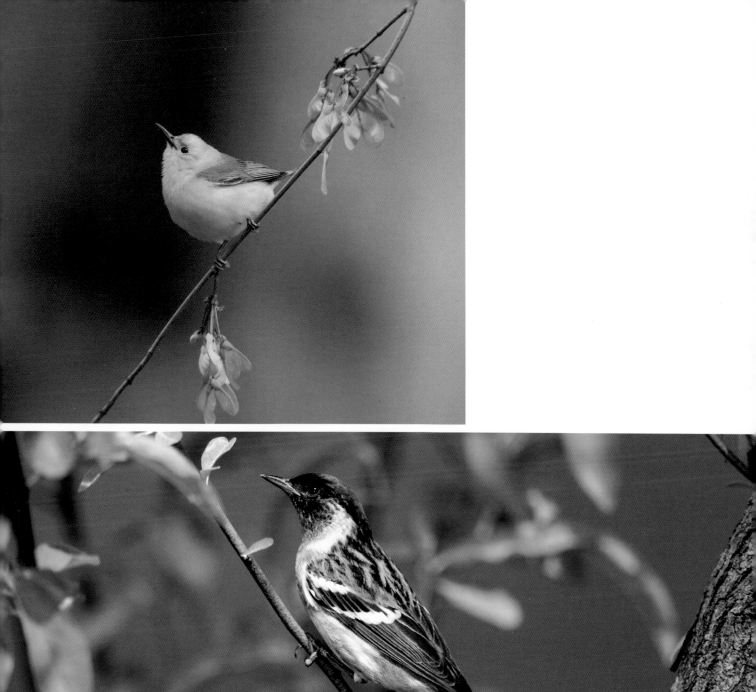

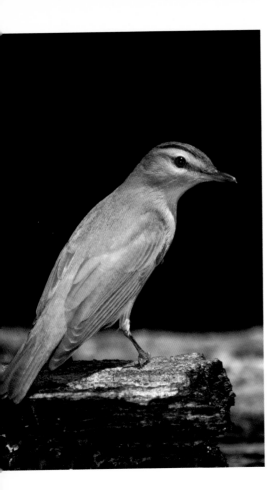

Red-eyed Vireo

The Red-eyed Vireo is one of the most abundant songbirds found in the forests of the eastern and central United States and Canada. They prefer deciduous forests where they can forage in the canopies of large-leafed trees, such as maples. Red-eyed vireos in western Canada move east before turning south and heading for their wintering ground in the Amazon basin. Red-eyed Vireos have olive backs, wings, and tails, with white underparts. A red iris accounts for the bird's name. There is a black line running through the eye with a white stripe just above that, and a dark stripe outlining the gray cap on the head. The Red-eyed Vireo's beak has a small hook at the end. This vireo was photographed during a termite hatch-out in the North Woods of Central Park.

Double-crested Cormorant

Double-crested Cormorants got their name because of the two tufts of black-and-white feathers that appear on their heads during breeding season. The Double-crested Cormorant is a stocky seabird with a long kinked neck, large webbed feet, and a long curved beak. It dives for fish and can swim great lengths underwater. Like other cormorants, its feathers are not waterproof so it must dry them off before it can fly. Cormorants are found from Florida to Maine, along the Gulf Coast and the Pacific coast from California up to the Aleutian Islands. They can feed in fresh or saltwater and live in colonies of stick nests on islands or shallow water. Populations had been in decline, but after 1972, when DDT was banned, they rebounded to such an extent that large colonies now have to be managed by wildlife agencies to prevent the decline of other colonial waterbirds. This cormorant is attempting to swallow a small-mouthed bass whole. You can see the neck expanding to accommodate the bulk of the fish.

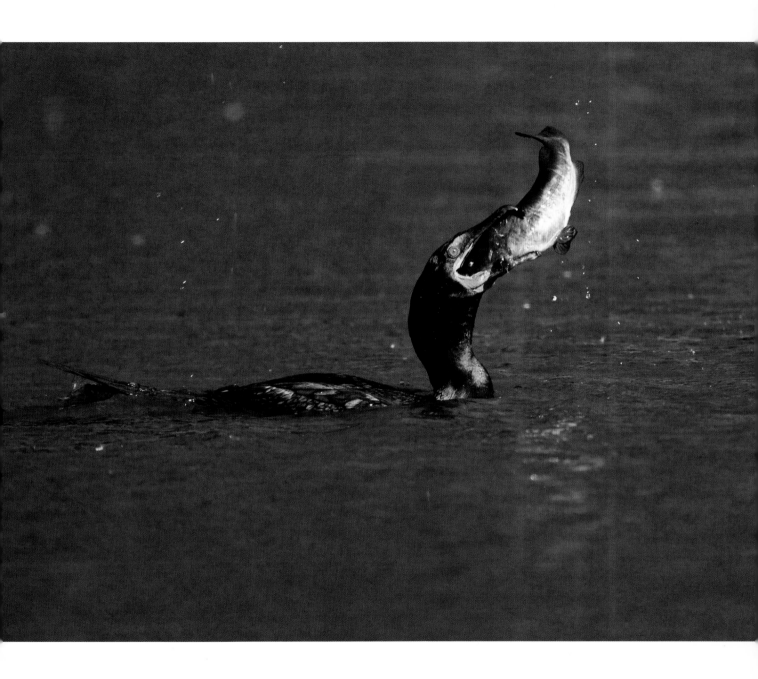

Great Egret

The Great Egret is a large, all-white heron with a yellow beak and black legs. They are a common sight in Florida and other Gulf Coast states, but can be seen all the way up the eastern seaboard into New England during the breeding season. They are also common along the Mississippi and in California up to the San Francisco Bay area. They are wading birds, feeding in swamps, coastal lowlands, mudflats, and estuaries. They were nearly hunted to extinction in the late nineteenth century; the voracious demand for their feathers, used to decorate ladies' hats, caused the death of hundreds of thousands of these elegant birds. Conservation efforts put an end to the wholesale slaughter, and the Great Egret has made a comeback since then. Great Egrets will often wait on docks for fisherman to return with their catch.

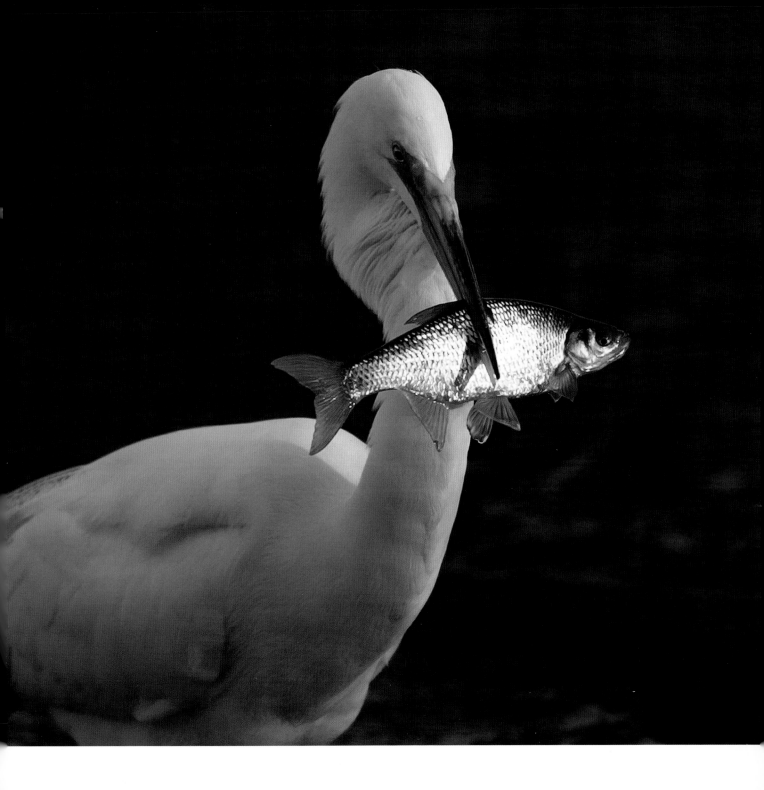

SUMMER

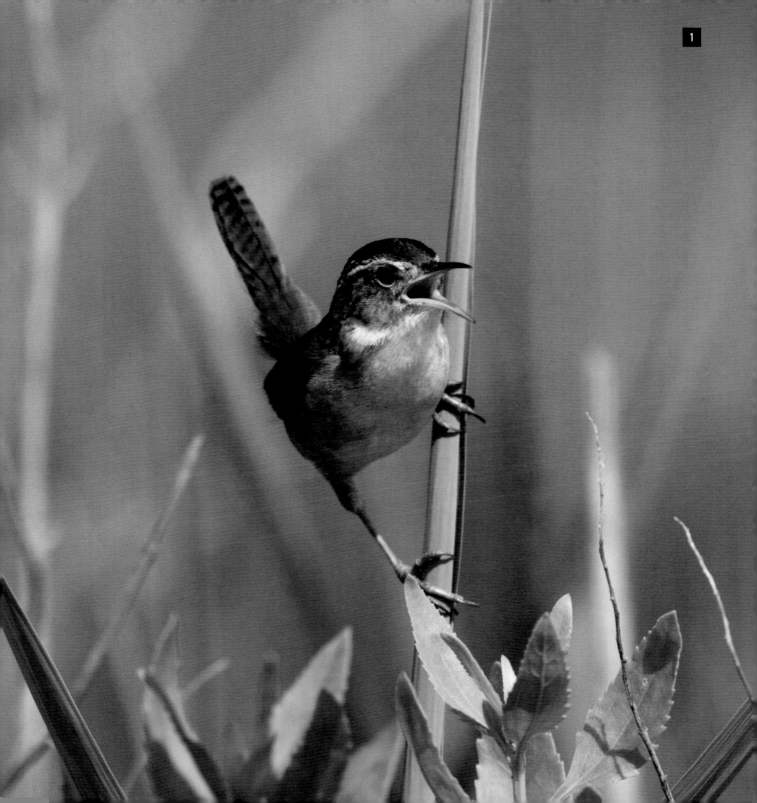

Marsh Wren 1

The Marsh Wren is a tiny brown bird with a white eye stripe and dark cap that breeds in marshland all across the north and central United States. While a year-round resident of the East, West, and Gulf Coasts and found all across Mexico, just about anywhere there are cattails or phragmites, you will find Marsh Wrens. The male is a prolific singer during both day and night and will build several "dummy" nests on his breeding territory, one of which he may use for sleeping. He may also puncture eggs of nearby nesting birds, including those of his own off-spring. Although the Marsh Wren is still fairly common, numbers are declining as marshlands are filled in across the country. The male sings a sputtering trill throughout the day and most of the night. Once his song is heard, it's only a matter of standing still until you get a glimpse of the bird. This Marsh Wren was encountered in cattails near the West Pond at Jamaica Bay Wildlife Refuge.

Ruby-throated Hummingbird 2

The Ruby-throated Hummingbird is the only hummingbird that nests in the United States east of the Rockies. Its range extends from the South up through New England and into southern Canada. Despite their tiny size, some Ruby-throated Hummingbirds migrate all the way from southern Mexico and Central America, many flying nonstop across the Gulf of Mexico to reach their wintering grounds. The Ruby-throated Hummingbird starts to be seen in our area in late April and may be found throughout the area all summer. The last Ruby-throated Hummingbirds linger until late September, feeding on flowers and at feeders. The male is characterized by an iridescent ruby-colored gorget beneath his chin, which he displays when agitated. Ruby-throated Hummingbirds' wings beat more than fifty times a second, and although they fly

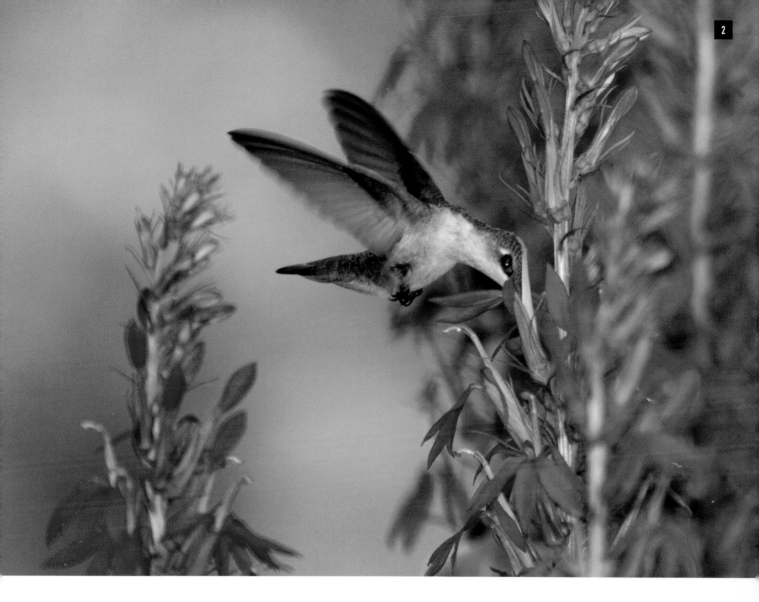

in a straight line, they can stop and change directions almost instantly and hover in place when feeding. This female Ruby-throated Hummingbird was photographed in the Shakespeare Garden in Central Park. The Shakespeare Garden has many hummingbird-friendly flowers and is an excellent spot to see and photograph them in spring and fall.

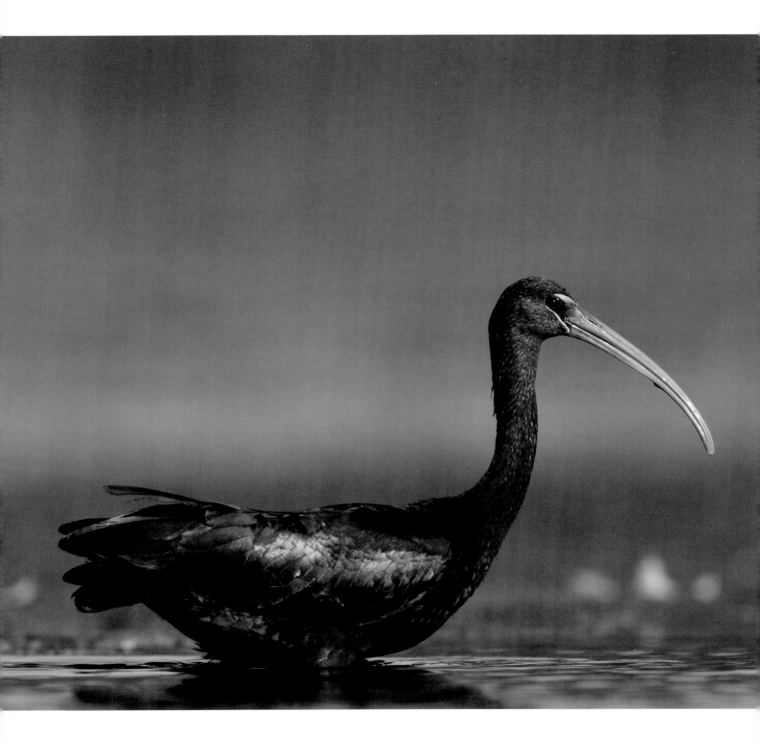

Glossy Ibis

The Glossy Ibis is a large wading bird found along the Atlantic coast in summer. Large flocks of Glossy Ibises move south in the fall to winter in Florida and the Caribbean. Glossy Ibises are found in Asia, Africa, Europe, and Australia. Historically, they are thought to have spread from Africa to South America then up through the Caribbean. The first recorded sighting of a Glossy Ibis in North America was in New Jersey in 1817. A curved bill and iridescent wing feathers are characteristic of this species. This photo was taken at the East Pond of Jamaica Bay Wildlife Refuge, not far from the islands in Jamaica Bay where Glossy Ibis breed. They are particularly skittish birds and hard to approach. I got close to this one by crawling in the muck on my stomach until I was in range for a decent shot. I took the shot at sunrise; the low angle of the sun highlights the iridescence of the wing feathers.

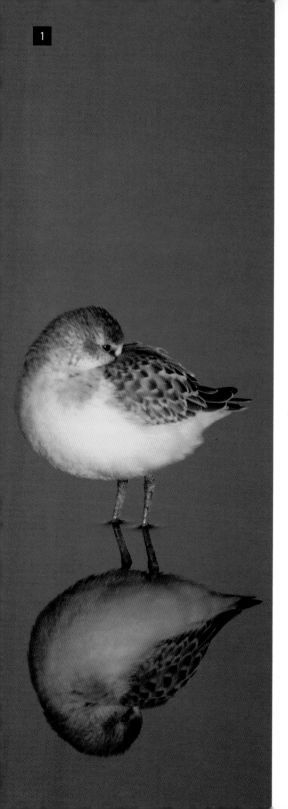

Least Sandpiper ▮

The Least Sandpiper is the smallest of all sandpipers, with a rounded body and short wings. In our area in summer, flocks of Least Sandpipers feed on mudflats and near most bodies of water (including on beaches) during migration. They have black beaks and green legs, which are sometimes hidden from view underneath the mud this bird likes to forage in. They breed all across the Arctic, from Labrador in north Canada to the Aleutian Islands in the Bering Strait. In the fall, Least Sandpipers migrate south to the southern United States, Mexico, and Central and South America along both coasts and through the interior of the United States. In spring, some will make their way north along the Atlantic coast, feeding on horseshoe crab eggs along the way. This bird was photographed at sunset in late summer at the East Pond of Jamaica Bay Wildlife Refuge and is probably a juvenile. Note the round body, characteristic of the species.

Yellow-crowned Night-Heron ▮

Yellow-crowned Night Herons are stocky wading birds that inhabit wetlands and marshes and feed mostly on crabs and crayfish. It is not uncommon to see a Yellow-crowned Night Heron standing stock-still for many minutes, only to plunge its beak quickly into the water and emerge with a crustacean. They will normally shake the crustacean until the legs fall off, then swallow it whole. The juvenile is cream colored with brownish stripes over the entire body. The adult is a grayish-purple with a cream-colored cap and a white streak below a red eye. A yellow feather streams behind the heads of adults, giving the species its name. The Yellow-crowned Night-Heron is a year-round resident of Mexico, Central America, northern South America, and the Caribbean. Its summer range extends as far north as Long Island, but it is

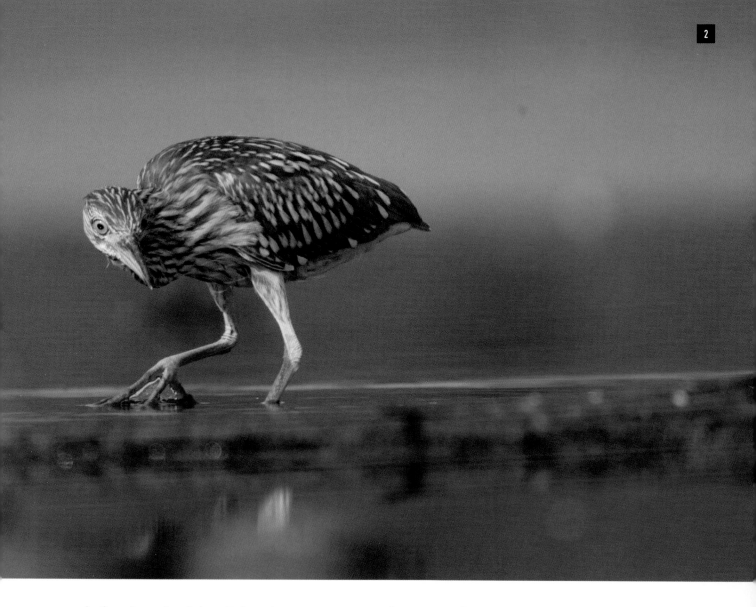

rarely found north of that. It is quite common in southeast coastal regions and seems to nest in colonies there, although it is a secretive and solitary bird at other times of the year. In this shot, a juvenile is slowly wading through shallow water in the East Pond at Jamaica Bay in search of prey.

Lesser Yellowlegs

The Lesser Yellowlegs is a medium-size shorebird with long yellow legs and a long beak. They nest in the Arctic tundra and move across the entire lower 48 states during spring and fall migration. Lesser Yellowlegs winter in shallow fresh and saltwater wetlands in the southeastern United States, Mexico, and Central and South America. In winter, they are also found on the Pacific coast from San Francisco south through Baja. As is common with Lesser Yellowlegs, these two are fighting over feeding territory. This shot was taken at the East Pond at Jamaica Bay Wildlife Refuge.

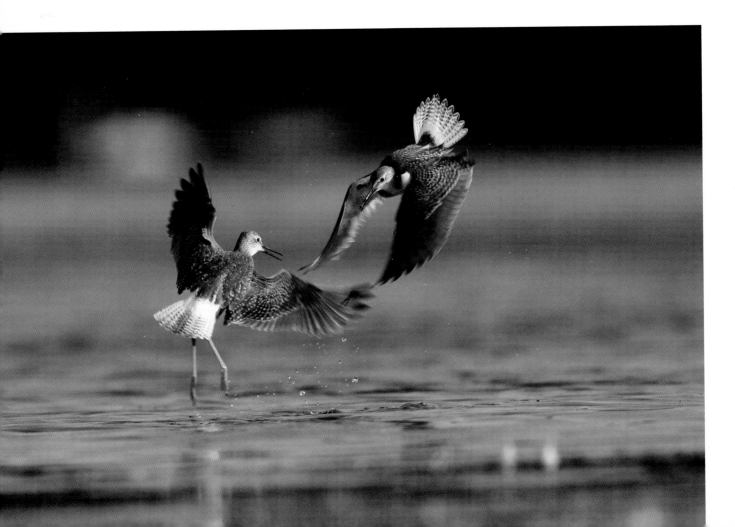

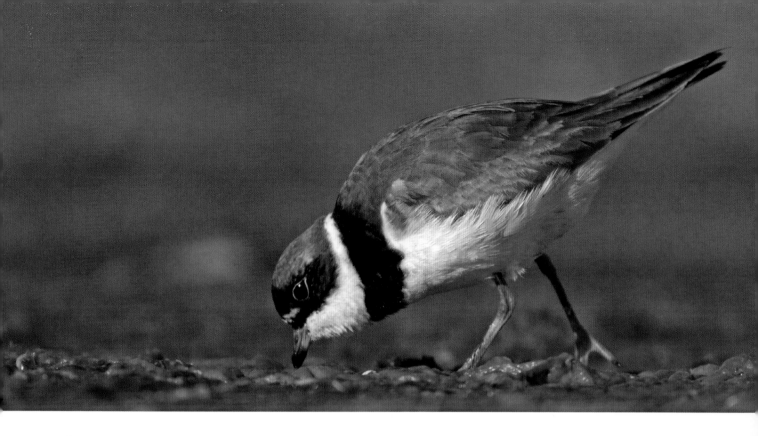

Semipalmated Plover

The Semipalmated Plover is a small shorebird with a black band around its upper chest and an orange beak tipped in black. It is the most common plover seen in our area during spring and fall migration. It nests in the Arctic tundra and winters along the West Coast and southern East Coast, the Gulf of Mexico, and Florida. Unlike other shorebirds that nest in the Arctic, the Semipalmated Plover avoids the tundra and prefers nesting in gravel beds in streams and along rivers and ponds. The coloration of the Semipalmated Plover breaks up its shape and effectively camouflages the bird sitting on the nest in this habitat. The name "semipalmated" refers to the fact the bird has webbing between its toes. This bird was photographed feeding in the early morning light of late August at the East Pond at Jamaica Bay Wildlife Refuge.

Black Skimmer

Black Skimmers are colonial birds that nest on Atlantic beaches from Massachusetts to Virginia in summer and along the southeastern and Gulf coasts throughout the year. Nesters from farther north tend to winter in southern Florida. They are also common on the coast of Southern California and down through the Baja Peninsula. There are colonies near Jones Beach and along the southern shore of Long Island. Many skimmer colonies are in or near tern colonies because terns are very aggressive in protecting their nest, and the skimmers benefit from this aggressiveness. Their name derives from the Black Skimmer's peculiar way of feeding by "skimming" for small fish just below the surface with their large beaks. This photo was taken at sunset at the East Pond at Jamaica Bay.

American Avocet

An elegant shorebird that breeds in the western United States and Canada and winters in Baja, the Gulf Coast of the United States, Mexico, and the Caribbean. Some migrate east and spend the winter along the Atlantic coast. It's a fairly large shorebird with a long, upturned beak that it uses to filter water for small creatures that live in the shallows. They are vulnerable to climate change that can dry up western inland lakes and prairie ponds. Although it is an uncommon visitor to our area, two or three seem to pass through during fall migration every year. This bird is feeding in the East Pond at Jamaica Bay Wildlife Refuge around sundown.

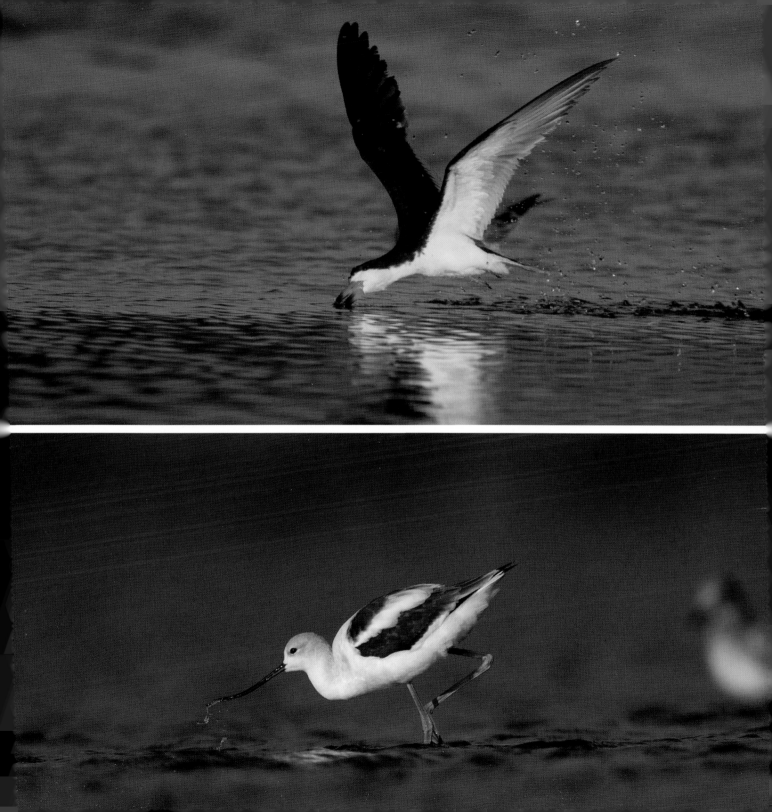

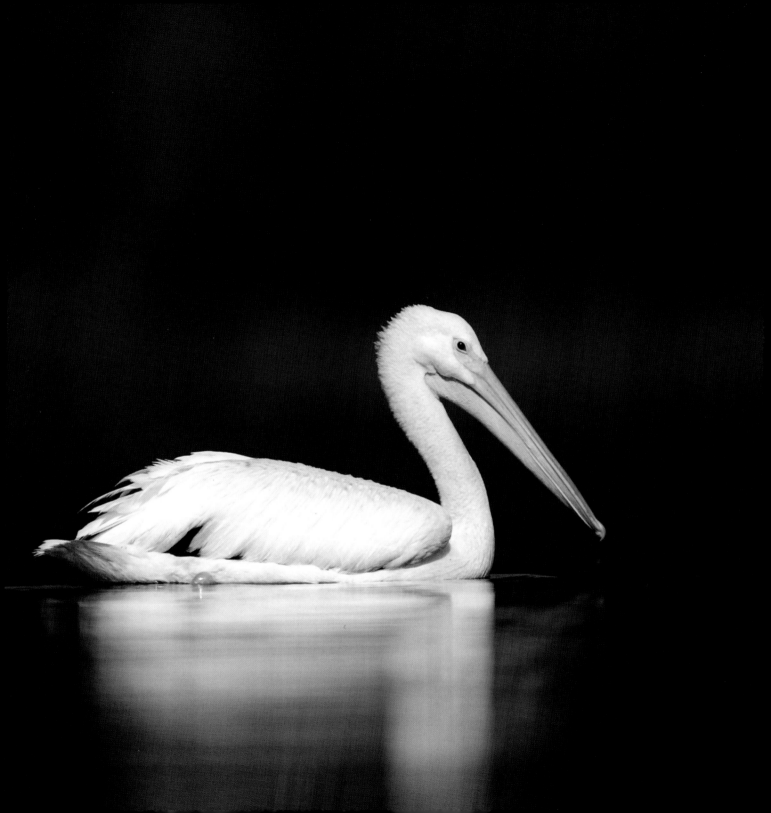

American White Pelican

The American White Pelican is one of the largest and heaviest flying birds in the world and is only rarely seen on the East Coast. American White Pelicans nest in the north-central United States and Canada and winter along the Gulf Coast down through Mexico. They also breed in some spots in the western United States and winter in Southern California and Baja. Unlike their cousin the Brown Pelican, the American White Pelican does not dive for fish from the air. They feed by floating on the surface and dipping their bill in the water to scoop up fish. Stray American White Pelicans are known to wander beyond their breeding grounds and have been observed in some areas of New England. This American White Pelican was photographed on the East Pond at Jamaica Bay Wildlife Refuge in late summer.

Tree Swallow

Tree Swallows are a common sight in parks and green areas in the New York metropolitan area. Amazing aerialists, Tree Swallows feed by plucking insects from mid-air with acrobatic dexterity. Adult males are white below and a dark iridescent blue-green on their heads and backs. Tree Swallows have also benefited from attempts to entice Eastern Bluebirds with nesting boxes as the swallows find the holes in these boxes perfect for their needs. Tree Swallows nest in most of the northern United States and Canada and winter along the southeastern and Gulf coasts of the United States, the Caribbean, and Central America. The nesting box in this photo is one of several installed around the West Pond at Jamaica Bay Wildlife Refuge. The managers of the refuge encourage swallows and bats to nest there as a natural way of keeping the insect population in check. The chick in this box seems large and may be one of the last to fledge. Tree Swallows typically lay between four to six eggs, and the parents are kept busy feeding nestlings that usually stay in the nest for 18–24 days after hatching.

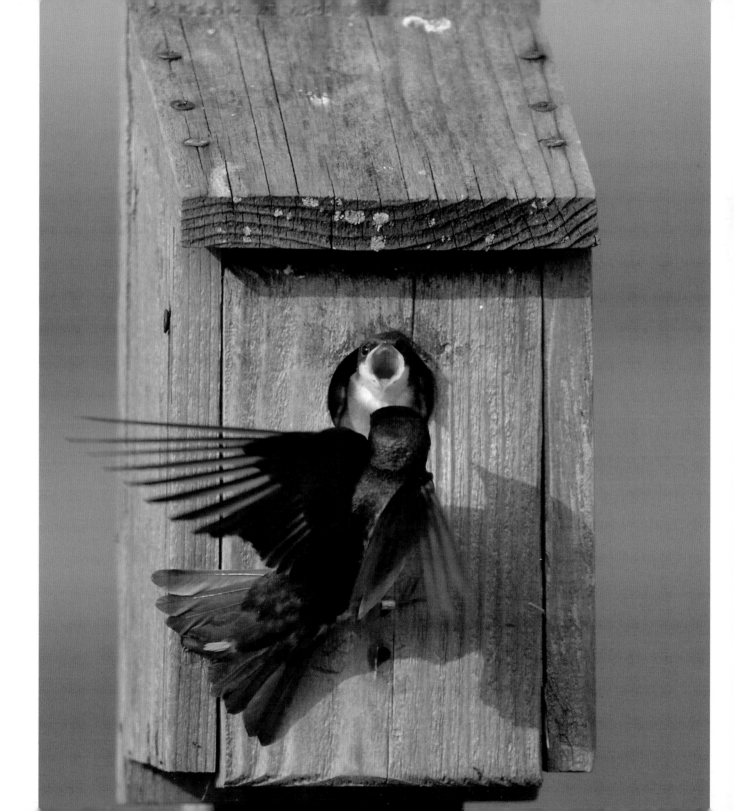

Common Yellowthroat

The Common Yellowthroat nests in most of Canada and just about every state in the continental United States, except for the dry southwest states. It is the only North American warbler that will nest in open marshland, and that behavior has helped the Common Yellowthroat thrive. The adult male is quite striking with his black mask and yellow chest. The female lacks a mask, although her neck and chest are yellow. Common Yellowthroats spend most of the time close to the ground searching for insects. They nest in the New York metropolitan area and winter in the Caribbean and Mexico. They can also be found in Florida and other Gulf states year-round. This particular female was shot at sunrise at Jamaica Bay Wildlife Refuge with the low rays of the sun painting her throat a brighter-than-normal yellow.

Great Blue Heron

The Great Blue Heron is a common sight across most of North America because it can survive on a varied diet. It often winters in northern climates as far north as New York and Massachusetts. In addition to eating small fish, crustaceans, snakes, and insects, it has also been observed consuming small waterfowl. It is also a year-round sight on the coast of the Pacific Northwest and all the way up to Alaska. It is the largest North American egret (although often referred to as a "crane"). This Great Blue Heron was photographed while he was wading in the duckweed-covered pool in the north end of Central Park. He seemed to be feeling along the bottom with his large feet until suddenly he struck and came up with this crayfish. Since the pool and every other lake in Central Park are man-made, the crayfish had to have been introduced. Since then, I have seen crayfish in the Harlem Meer and observed Mergansers diving for them in the Reservoir on many occasions (See page 100 for a photo of female merganser).

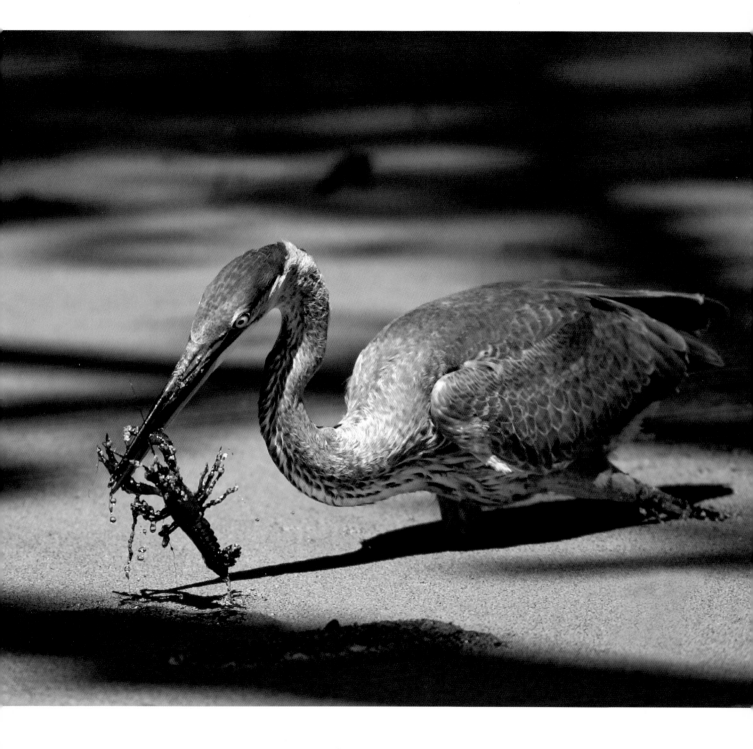

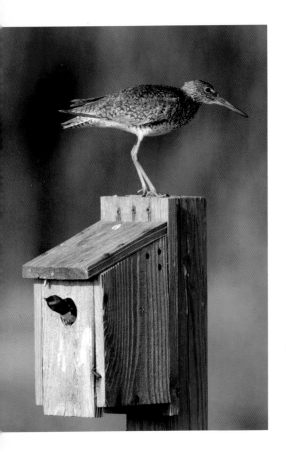

Willet

Willets are large, long-legged sandpipers that breed along the Atlantic coast from Nova Scotia through Delaware and winter farther south along the Florida coast, the Gulf of Mexico, and on islands in the Caribbean. They feed in mudflats and along beaches and rocky shores, and can often be seen standing on a rock in their characteristic one-legged stance. It's easy to recognize a Willet in flight because of the black-and-white stripes on their wings. The Willet's population on the East Coast was sharply in decline by the end of the nineteenth century as a result of indiscriminate hunting. After hunting was curtailed, the population recovered, although the birds are still threatened by habitat loss. Willets are a common site at Jamaica Bay Wildlife Refuge, where this photo was shot. Willets can often be seen standing on swallow boxes, but this is the first time I ever saw a Tree Swallow take notice.

Wood Thrush

The Wood Thrush has a bold white eye ring and reddish head, back, and sides. Its neck and protruding belly are white and heavily spotted. There is no difference in coloration between males and females. Wood Thrushes feed on insects in the leaf litter and can be seen bobbing up and down and scraping away leaves in search of insects. They also feed on fruits and berries. Each pair may produce two broods during the mating season, although not exclusively with each other. Wood Thrushes prefer mature deciduous forests in the eastern United States, and a pair has been observed breeding in the Ramble in Central Park over the course of several seasons. The birds winter in the Yucatan and Central America. Wood Thrushes are very susceptible to nest parasitism by Cowbirds, readily accepting Cowbird eggs where other species will reject them. Along with habitat destruction, this has led to an overall decline in the numbers of Wood Thrushes.

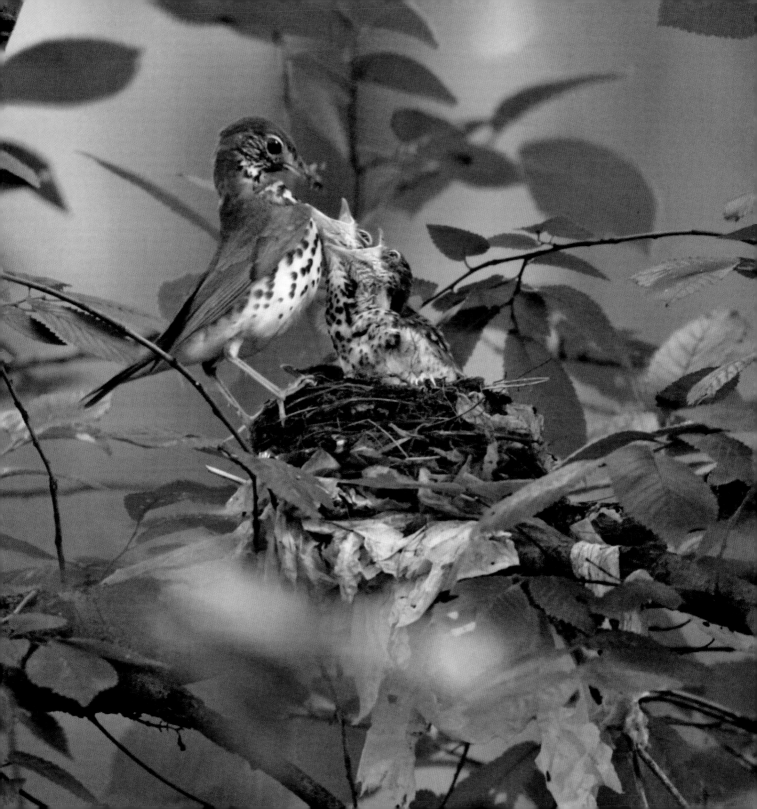

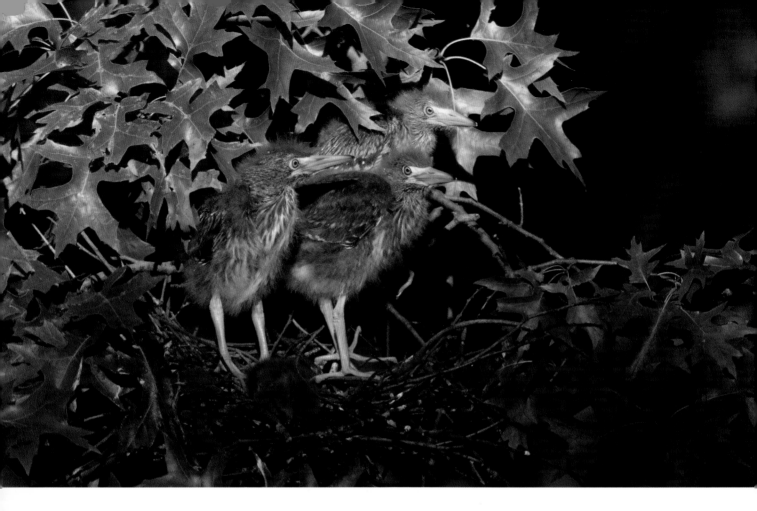

Green Heron

Green Herons breed in the eastern and central states and along the Gulf Coast down to the Yucatan, and also in Southern California and Baja. They usually prefer nesting near quiet bodies of fresh water surrounded by dense trees and shrubbery—but the pair that created this nest and hatched these chicks seem to have different tastes. Their nest was located in the Upper Lobe of Central Park Lake, and they came back to the same spot for at least five breeding seasons. After more than a year of work on the Upper Lobe in 2013, the pair found another

place to nest, presumably in a more secluded area. Year after year they raised a brood of at least three chicks, flying back and forth to the nest to feed the hungry nestlings with regurgitated food. These chicks are gray and have yet to grow out their flight feathers. Adult Green Herons have darkish red breasts and necks, and dark green iridescent feathers on their wings and backs. They are rather short and squat as herons go, with yellow eyes and a long beak. There is no difference in color between males and females. In this photo, three chicks await the return of a parent with food while the body of a fourth, the runt of the litter, can be seen in the lower left corner. Never able to compete with its larger siblings, this smaller chick was doomed.

Canada Geese

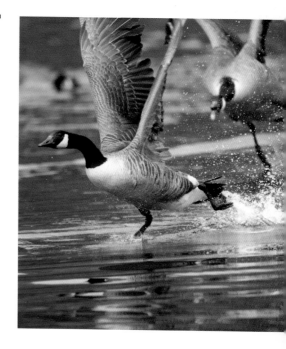

The Canada Goose is often wrongly referred to as "Canadian Goose." Although this large waterfowl is found throughout Canada, it also traditionally migrates south to the southern United States in fall and heads back to Canada in spring. Migrating Canada Geese are a common sight in the skies over the New York metropolitan area, but in recent times geese have adapted well to urban areas and can now be found throughout the year in local parks and refuges. Some estimates say the Canada Geese population has tripled in the past ten years. In some places, they have become a nuisance with their aggressive behavior, up to the point that the Central Park Conservancy hired the "Geese Police" to chase the birds out of Central Park (with little to no effect). Wildlife officials in the area have also tried to reduce the Canada Goose population by oiling or turning the eggs in the nest so they would not hatch. Time will tell if their efforts are successful, but so far the Canada Goose population does not seem to be heading for a decline any time soon. In this photo taken at the Harlem Meer, one Canada Goose is chasing another in a typical goose-to-goose confrontation.

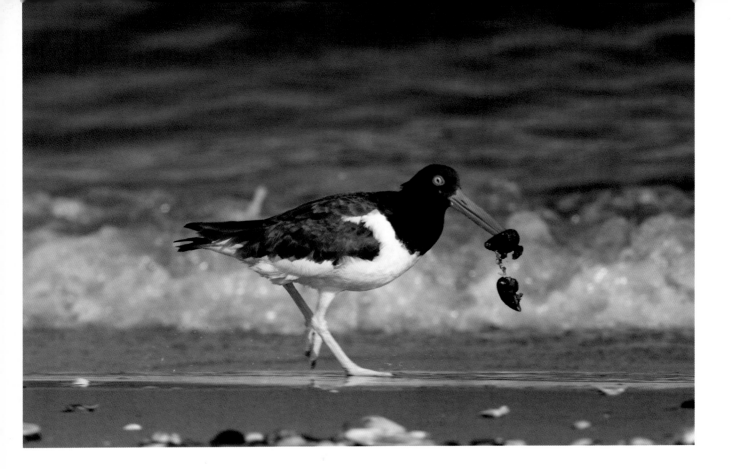

American Oystercatcher

A common sight in the summer on local beaches and north through New England and south along the Gulf Coast. American Oystercatchers winter in Florida and the Caribbean and return in late March. In our area, American Oystercatchers nest on islands in Jamaica Bay and at Breezy Point, part of Gateway National Recreation Area, and on other beaches of Long Island. This large bird with a bright red bill is hard to miss as it runs through the surf foraging for clams, mussels, and oysters. Males and females are identical, with black heads, large yellow eyes, white undersides, and brown backs. They also have red rings around their eyes and distinctive pink legs and feet. Their long bills are

well suited for splitting open clam and oyster shells and sucking out the contents. In this shot, an Oystercatcher is running along the beach at Breezy Point with its beak jammed firmly in a bivalve.

House Wren

This small brown wren is the most common bird in the Western Hemisphere. Its range extends from Canada to the tip of South America. House Wrens got their names long ago for a tendency to nest in bird houses or near human homes. They will easily take to nesting boxes or almost any discarded receptacle that offers some privacy and protection. The House Wren is a darker brown on top and a lighter brown on the bottom, and has a fairly long, curved beak. It also sports a long tail, which it cocks at a jaunty angle as it forages for food. They are insectivores, as you can see by this photo, and they typically hatch five to seven eggs each in two or more broods a year. The House Wren in this photo nested in a tree cavity in the Ramble in Central Park, but others have nested in boxes erected by the Parks Department in the north end of the park.

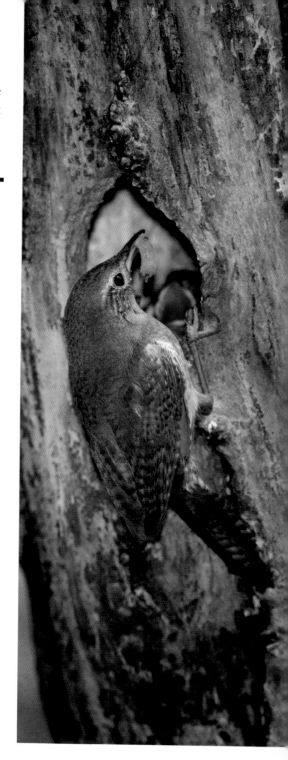

Piping Plover

Piping Plovers are a federally protected species that nests in three distinct geographical areas of North America. There is a nesting population along the Atlantic coast (including the New York metropolitan area) as well as a population in the Great Plains and around the Great Lakes. The Great Lakes population has almost completely vanished and is listed as an endangered species there by the United States Fish and Wildlife Service. All three populations winter along the Gulf Coast down through the Yucatan and in a small area of Cuba. Piping Plovers on the Atlantic coast nest in grass at the edges of beaches. They make small depressions in the sand where they lay their eggs. The nests are very exposed and subject to predation by birds, snakes, and small mammals—as well as destruction by careless beach walkers. At Breezy Point and along other beaches on Long Island where Piping Plovers nest, the United States Fish and Wildlife Service has placed cages over the nests in an attempt to protect them from predators and humans. They are a common sight in spring and summer as they skitter along the beach above the surf line, running and stopping, running and stopping, all the while watching for telltale air holes sending bubbles up from the sand where worms and small crustaceans have burrowed. This photo is of an adult and chick at Breezy Point. This adult (males and females are almost identical) is sitting out in the open with a chick next to it. You can see the legs of another chick sticking out below the breast of the adult.

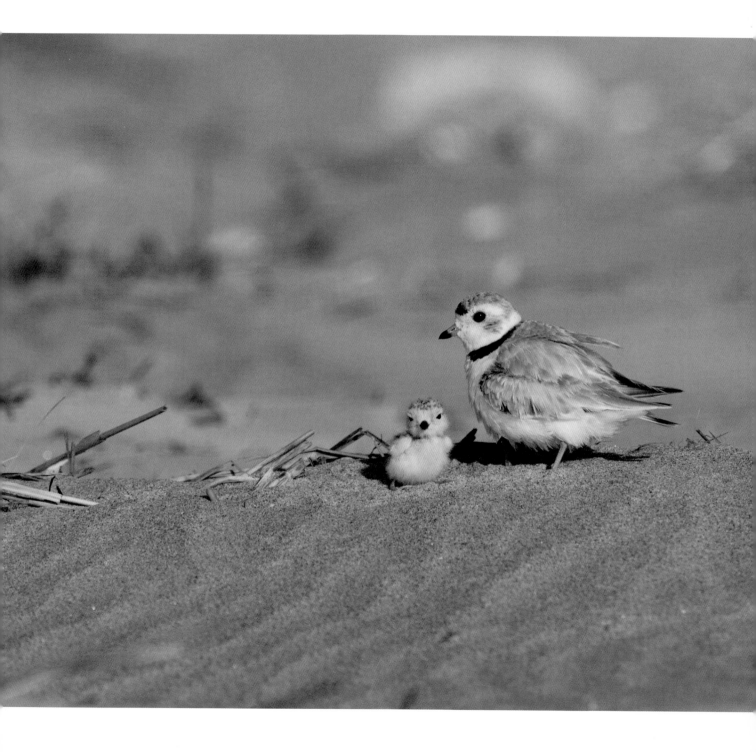

Connecticut Warbler

Although the Connecticut Warbler moves through the New York area during migration, its nesting grounds are far to the north and west in Canada, and the bird is rarely seen here. As with other birds, the Connecticut Warbler was first observed in that state, and the name stuck. The species is quite secretive and skulks around near the ground searching for food. It migrates to its wintering grounds in the tropics of South America through the middle of the country, although some birds do follow the Atlantic coast. In its breeding plumage, this warbler has a gray hood and throat set off by yellow undersides. It is a relatively large warbler with a prominent eye ring in all seasons. This bird was photographed near Central Park Lake, and there is no way to be sure if it is a female, male in non-breeding plumage, or juvenile. At the time, birders flocked to the location where this bird was seen, only to find a street musician who had staked out the same spot. The street musician had commandeered the same spot for several years in a row and was not happy with the influx of birders and photographers ruining his performance.

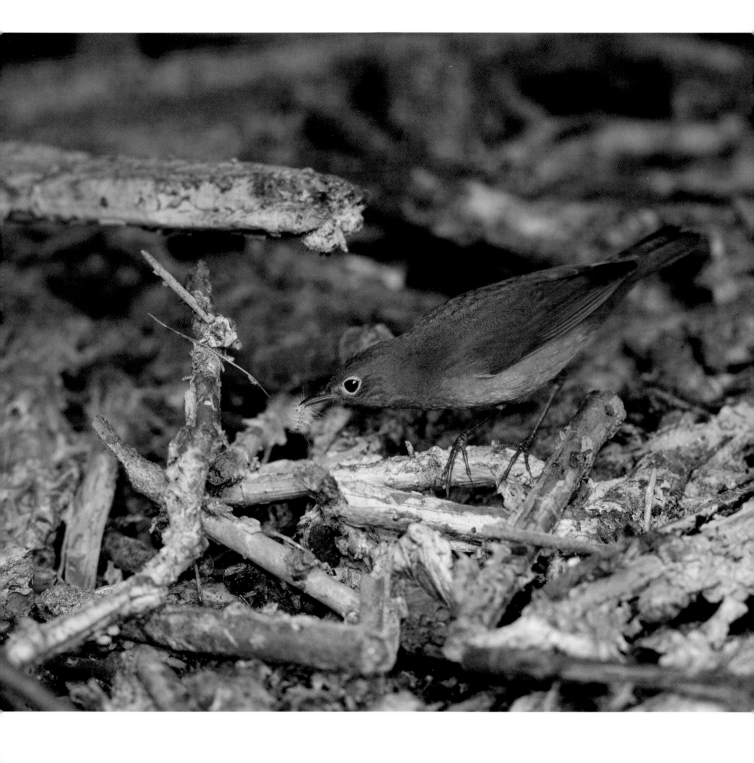

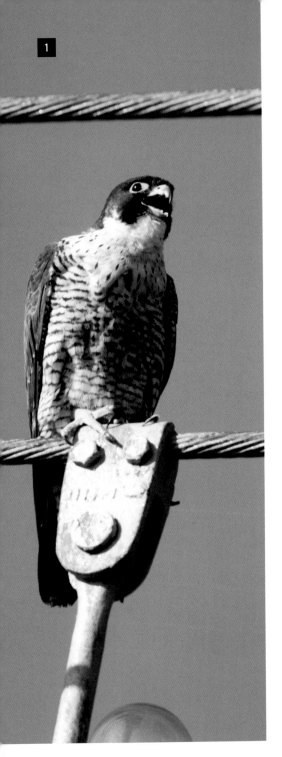

Peregrine Falcon ▮1

By 1964, there were no nesting Peregrine Falcons to be found east of the Rockies. DDT, an insecticide introduced during World War II, had found widespread acceptance in the United States without extensive testing and study. DDT entered the food chain and the Peregrine Falcon, as an apex predator, consumed enough of it to make its eggs inviable. The Peregrine Falcon eventually became listed as an endangered species. After DDT was banned in 1972, a Peregrine Recovery Plan was instituted in the eastern United States. As a result, by 1999 the Peregrine Falcon was removed from the endangered species list. No one is sure exactly when Peregrine Falcons began nesting on buildings in New York City, but pairs have been nesting on the George Washington Bridge, Riverside Church, and the Brooklyn Bridge for some time now. This photo shows a juvenile Peregrine Falcon on the support wires of the Brooklyn Bridge. The bird has just recently left its nest in one of the bridge towers and is waiting to be fed by an adult.

Snowy Egret ▮2

Snowy egrets are one of the smallest herons in North America and a common sight in our area through almost all four seasons. They nest in colonies on islands in and around the New York City area as well as up and down the East and Gulf Coasts. They are late to leave in the fall and early to arrive in spring. Snowy egrets in the north that move south for the winter do not go very far. They are also found year-round across most of South America. The adult male is a brilliant white with a black beak and legs and yellow feet. They have a long, thin neck that they retract when standing or flying. Snowy egrets are active feeders and move rapidly through shallow water looking for food. They are also territorial, as seen in this photo where a Snowy Egret is about to land and chase another bird from its feeding ground at the East Pond at Jamaica Bay Wildlife Refuge.

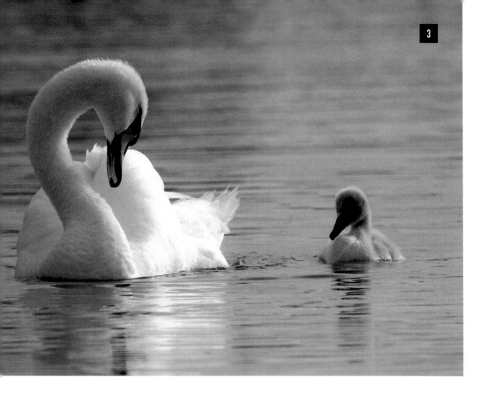

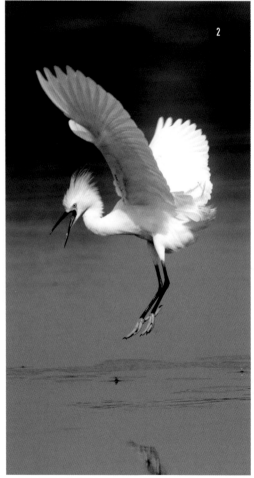

Mute Swan 3

Mute Swans are native to Europe and Asia and were imported into the United States in the nineteenth century as ornamental additions to parks, golf courses, and private estates. Since then, Mute Swans have spread throughout the Northeast and Great Lakes regions, and even advanced as far as the Pacific Northwest. The Mute Swan is not mute, but it is quieter than native species of swans, hence the name. Since their introduction, Mute Swans have flourished to the point that some consider them a public nuisance. Their aggressive behavior, coupled with their ability to strip a habitat of all plant matter and force out other waterfowl, have made this large swan unwelcome in many areas. Recently the New York State Department of Environmental Conservation put forth a plan to eradicate all Mute Swans from Jamaica Bay and surrounding areas. That plan has since been held in abeyance. In this photo, an adult looks down on a cygnet at the East Pond of Jamaica Bay Wildlife Refuge.

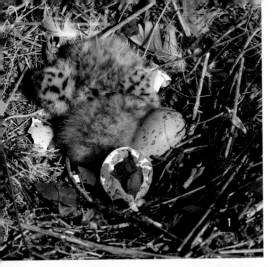

Herring Gull ▪1

The Herring Gull is a large gull that nests in northern Canada and along the East and Alaskan coasts of the United States. There are also several year-round populations around the Great Lakes and some on the East Coast, but many of the nesting birds from Canada move south for the winter. They are probably the most common and easily recognizable gulls along the East Coast and in the New York metropolitan area. Adults are pink-legged with gray backs, white undersides and heads, and black wingtips. Mature adults have a red spot on the lower mandible near the tips of their beaks. Although they prefer freshwater, they have the ability to drink saltwater and are seen in and around almost every body of water in the New York area. This nest with two chicks and an unhatched egg was photographed in early summer on one of the smaller islands in Jamaica Bay.

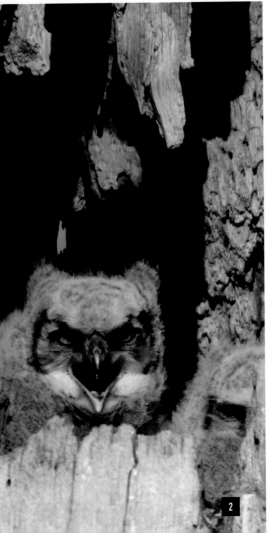

Great Horned Owl ▪2

The Great Horned Owl is one of the largest and most common owls in North America. Although the Snowy Owl is typically smaller, it weighs more than a Great Horned Owl. The Great Horned Owl is a year-round resident in every U.S. state along with Mexico and large parts of South America, with many subspecies in specific geographic areas. Its plumage is varied brown and gray and provides excellent camouflage for the bird as it sleeps in trees during the day. Distinguished by two tufts of feathers on either side of the head, the Great Horned Owl is a common sight in the area and breeds in many of New York City's parks. These tufts are often confused with ears, but the owl's actual ears are beneath the tufts, on the sides of its head. Its eyes are almost as large as humans', and they're adapted for seeing in low light. The Great Horned Owl's call is a loud, low "who-who-whoh whoh whoh" that has led to some to

call it a "Hoot" owl. This nest was on Hunter Island in the Bronx. Great Horned Owls have been nesting there for more than a decade, according to local birders. When this particular hollow tree rotted away and fell, the owls moved to another nearby tree the following year.

Red-winged Blackbird 3

Red-winged Blackbirds are very common in our area and across most of the United States and Canada. They can be found in almost any marshy area, where they build nests among cattails and rushes. They nest in all forty-eight states, and northern birds in Canada will move south into the United States to overwinter. They are among the first birds to arrive on their nesting grounds in the north and herald the approach of spring. Males are very aggressive when defending their nest and will attack larger birds—and even humans—who stray too close. In this photo, a newly fledged Red-winged Blackbird is attempting to remove a peanut from its shell.

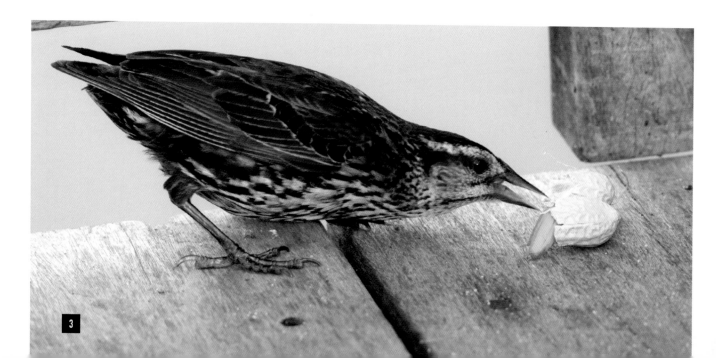

3

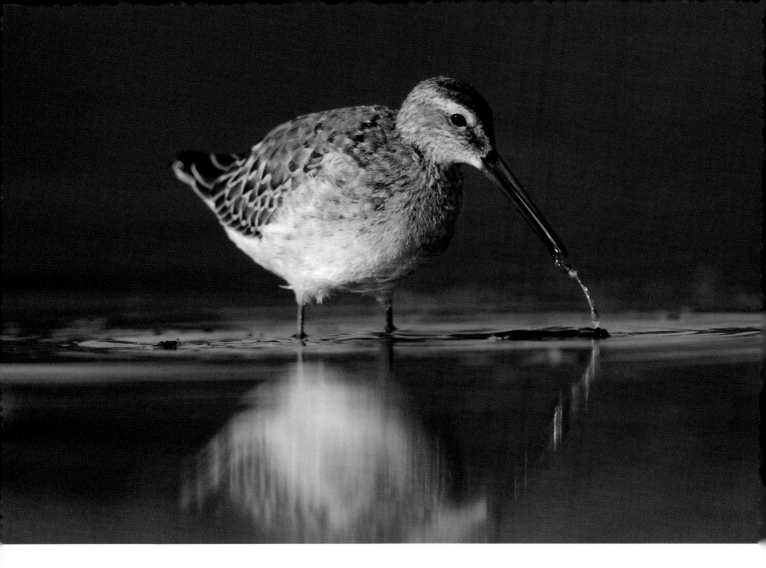

Stilt Sandpiper

The Stilt Sandpiper is a small sandpiper often confused with a Dow-
itcher because they are of roughly the same size and the two birds are
often found in mixed flocks. They also feed like Dowitchers, jabbing
their long bills into shallow water in search of worms and other small
invertebrates. Like many sandpipers, Stilts breed in the open Arctic

tundra of North America and make a twice-yearly journey to and from their wintering grounds in northern South America. Some also winter along the Gulf Coast and in southern Florida. They are found along the East Coast and also in the central United States and Canada during spring and fall migration. In their breeding plumage, they have heavy bars on their underside and reddish cheek patches. This bird is a juvenile or an adult in the process of shedding breeding plumage. This Stilt Sandpiper was photographed at the East Pond at Jamaica Bay in late summer.

Wilson's Phalarope

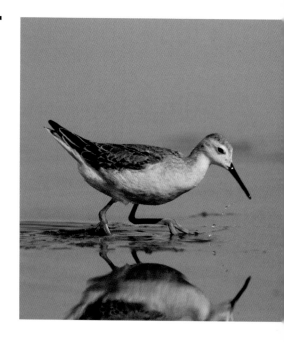

Wilson's Phalaropes are small shorebirds that breed in the western United States, Canada, and some areas of the Great Lakes. Rarely seen in our area, they winter in South America and gather at large salt lakes in the West in large flocks for the journey to the western coastal areas of South America and Argentina. Female Wilson's Phalaropes are more colorful than males. In breeding plumage, they sport a gray cap with a black slash through the eyes and down the back of the neck and a dark red coloring on wings and back. The front of the neck is a reddish-pink and the undersides are white. In non-breeding plumage, it is hard to tell male from female. The Wilson's Phalarope has lost vast tracts of nesting area due to the draining of prairie ponds and marshes in the West. This Wilson's Phalarope was photographed at the East Pond of Jamaica Bay Wildlife Refuge, where one or two may pass through in late summer.

Northern Flicker

The Northern Flicker is native to most of the United States, Mexico, parts of Central America, and Cuba. It also nests throughout most of Canada and is one of the few woodpeckers that migrates. Northern Flickers are large for woodpeckers, with distinctive coloration and markings. They are brown overall with black spots on their chests and black scallops on their wings. Males and females have a distinctive black "bib" on their neck, and the male also has a red cap on the back of his head. Both male and female show bright yellow under their wings and tails. Flickers forage on the ground for food, eating mainly beetles and ants, although they will eat ripe fruits and berries in the fall. This Northern Flicker male is looking into a nest cavity in a tree next to West Park Drive in Central Park. The pair of Flickers that nested here successfully fledged three chicks in late summer.

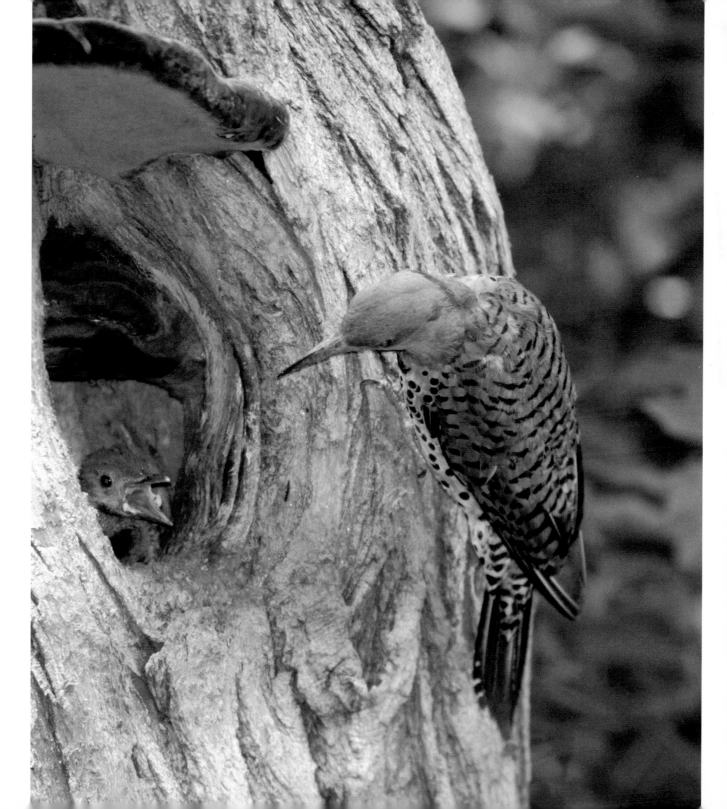

Common Tern

Common Terns are indeed very common in the Northeast. They breed along the East Coast from Virginia all the way up north to Labrador in Canada. Almost all Common Terns in North America winter in South America along the coast as far south as Peru and Argentina. Some migrants linger through December before heading south and may even be seen in New York City in early January. Common Terns are also found inland around the Great Lakes and north through the midsection of Canada. These birds also winter in South America. Coastal Common Terns breed in a concentration of colonies in protected areas along the coast. Common Terns live mostly on a diet of small fish; they can drink saltwater because, like other gulls, they have nasal glands that excrete excess salt from their systems. This photo of an adult feeding a fledgling was taken at the East Pond of Jamaica Bay Wildlife Refuge Area. Many fledgling Common Terns often spend much of their early lives at the East Pond.

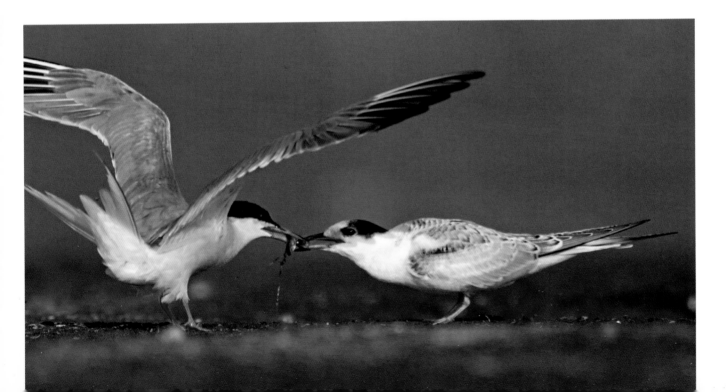

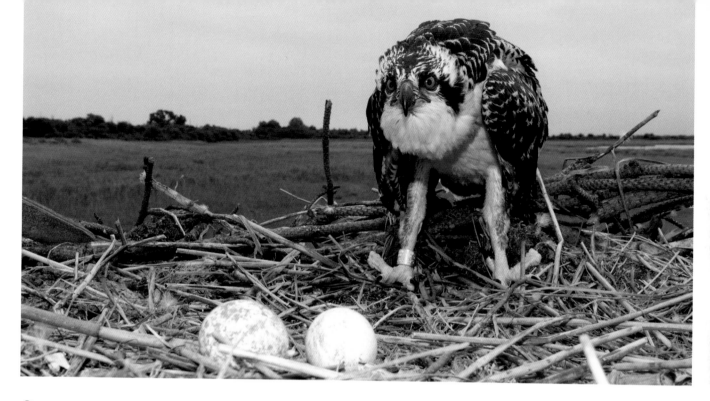

Osprey

Ospreys, like Bald Eagles, suffered a serious decline in numbers in the first half of the twentieth century. It was only after DDT was banned in 1972 that Ospreys began making a comeback and are now found in sustainable numbers nearly worldwide. They nest in treetops, on platforms erected specifically for that purpose. Ospreys breed along the East and West Coasts, the Great Lakes, and in northern Canada and Alaska. They live year-round in Florida and other Gulf Coast states and winter in the Yucatan, Central America, and most of South America. Ospreys are a common sight over most of America during migration and are easily identified by the "M" shape they make when they fly. They are one of the few raptors to eat only fish, and can often be observed flying with a fish held facing forward. This chick on a platform in Jamaica Bay Wildlife Refuge had just been banded and placed back in the nest. Two eggs that will never hatch are in the front of the shot. They were gathered by wildlife biologists to determine why they did not hatch.

FALL

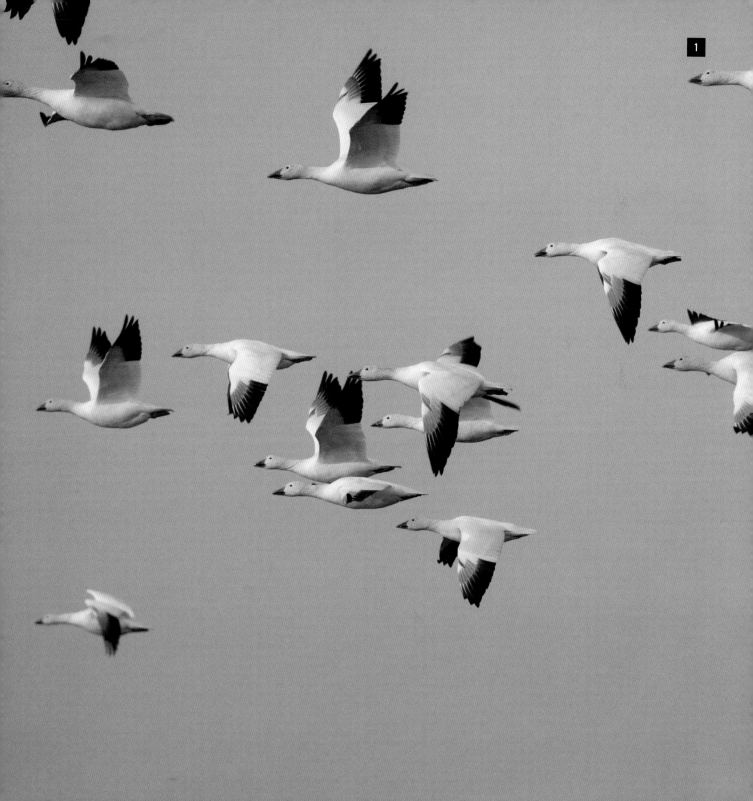

Snow Goose 1 2

Snow Geese breed on the Arctic tundra and spend the winter months concentrated in certain areas of the United States and Mexico. Although strays are frequently seen in Scotland, Snow Geese are found mainly in North America. Their numbers have skyrocketed as huge flocks of wintering birds have discovered the advantages offered by leftover crops in harvested agricultural fields in the eastern and the southern United States and Mexico. Snow Geese flocks can number in the hundreds of thousands, and there is no more spectacular sight than thousands of Snow Geese honking as they take flight. Snow Geese form strong family bonds while migrating south from the Arctic tundra. Only as they return to their breeding grounds do the yearlings leave the group to start their own families. Snow Geese are all white with pink feet and bills, and black wingtips that are hardly noticeable on the ground but visible in flight. This Snow Goose is sleeping with one leg tucked into its body and is one of several hundred observed at the West Pond of Jamaica Bay Wildlife Refuge in Queens.

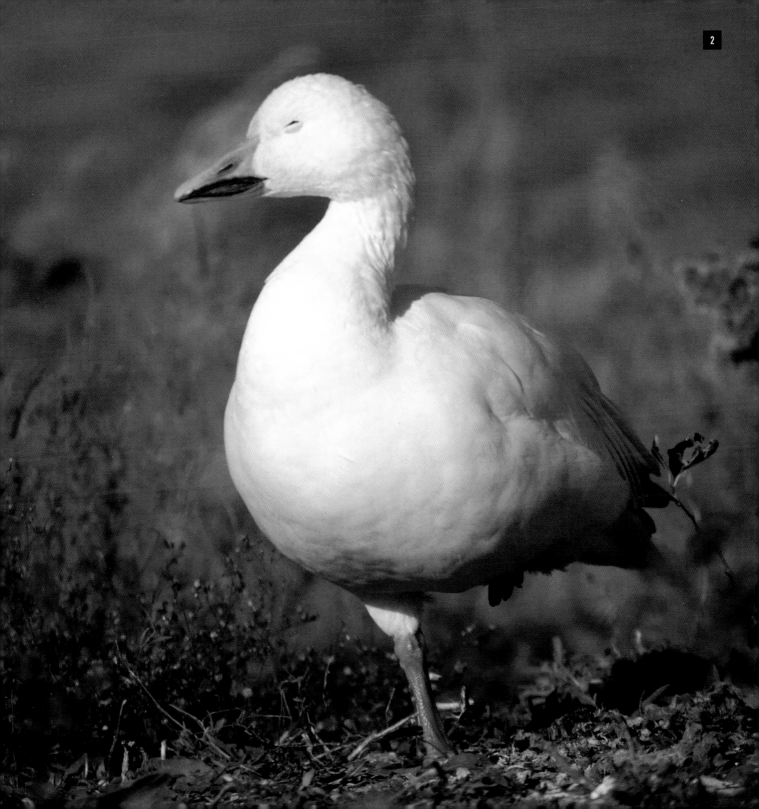

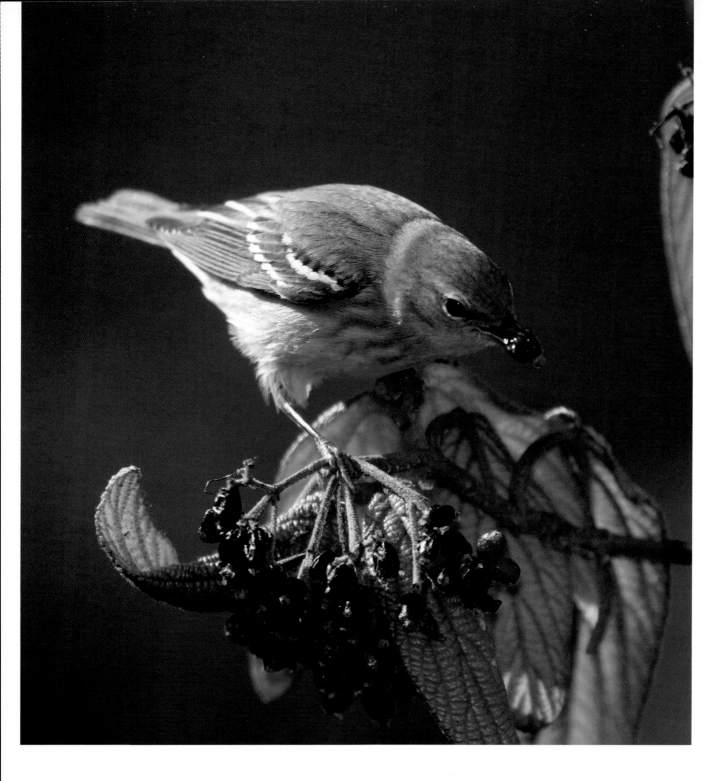

Blackpoll Warbler

This female Blackpoll Warbler is feeding on the ripe berries of a viburnum bush in Central Park. The sweet berries attract migrating birds heading south in late summer and early fall. The female Blackpoll Warbler looks nothing like the male. While both have yellow-orange legs and feet, the female is an olive color that fades to gray on her back. Like the male, she has two white wing bars; unlike the male, she has a white eye stripe. During spring migration, Blackpoll Warblers travel north over land, but in the fall they gather in Nova Scotia for a nonstop trip over water to their winter grounds in the Antilles and South America, often flying more than 72 hours nonstop. In spring, the Blackpoll follows a more leisurely pace through the Caribbean and up the eastern coast of the United States and Canada. Male and female usually migrate separately, with the male arriving earlier on the breeding grounds to prepare the nest.

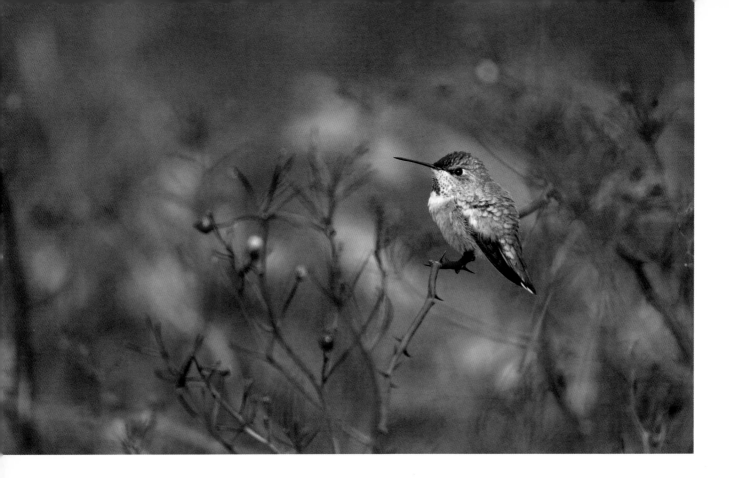

Rufous Hummingbird

Although the Rufous Hummingbird is a Western species nesting as far north as Alaska, it is being seen more frequently in the East and South in the fall and winter. The Rufous Hummingbird is one of the smallest hummingbird species, but makes up for its size with its aggressiveness. Known for actively guarding its feeding territory, the Rufous Hummingbird will go after much larger hummingbirds, even during migration. This tiny bird winters in southern Mexico and nests farther north than any other hummingbird species. Every year vagrants are found east of the Mississippi. The bird in this photo was seen throughout late November and December in Strawberry Fields in Central Park.

White-throated Sparrow

White-throated Sparrows breed across most of Canada and in parts of some northern U.S. states, and winter in most of the eastern and the southern United States. They can also be found along the West Coast in winter. The male has a very distinctive call, which many birders in the United States liken to "Old-Sam-Peabody-Peabody." Canadians, meanwhile, think it sounds like "Oh-sweet-Canada-Canada." While the White-throated Sparrow does, indeed, have a white throat, it also has a distinctive black crown with a white stripe down the center and white stripes on either side that end in yellow patches just forward of the eyes. White-throated Sparrows sing their song throughout the year and are a common sight in the tristate area in late fall and winter.

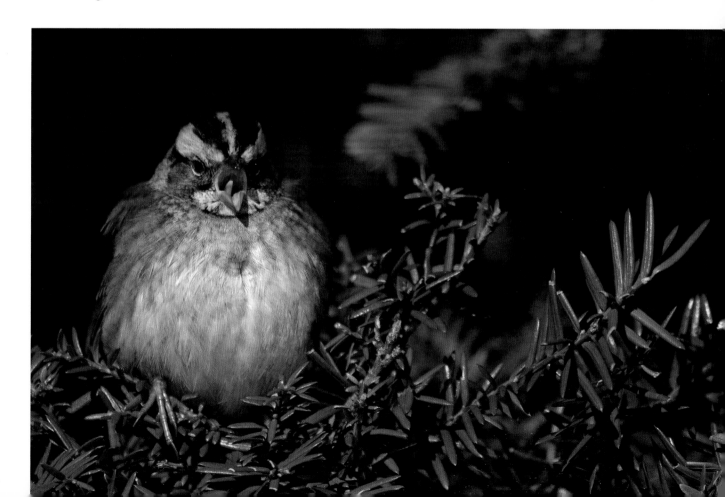

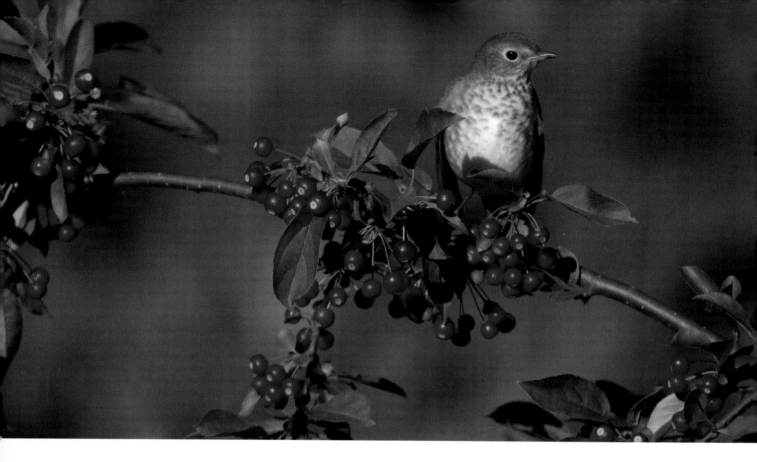

Hermit Thrush

The Hermit Thrush is a medium-size member of the thrush family, which includes robins and bluebirds. It has a shape similar to an American Robin, only smaller. The Hermit Thrush's head and back are covered by rich brown feathers, and it has a lighter throat and breast with spots running from the neck downward, becoming "smudged" the farther down they go. The haunting song of the Hermit Thrush has inspired many poets, including Walt Whitman and T.S. Eliot. A slightly altered version of its song can be heard in the *Hunger Games* movies, standing in for the song of the fictitious Mockingjay. Hermit Thrushes breed in the coniferous forests of the northeastern United States and

across most of Canada. It migrates north earlier in the spring and lingers longer in the fall, and is one of the only thrushes likely to be seen in the Northeast in winter. Most Hermit Thrushes winter in the southeastern United States and Mexico. Hermit Thrushes scrape in leaf litter for insects and earthworms, and often wander into cleared areas or forest trails. In addition to a diet of insects, Hermit Thrushes eat a variety of berries, especially in winter. This Hermit Thrush was photographed on a branch full of ripe berries in Central Park.

Red-bellied Woodpecker

Originally a bird of the Southeast, this member of the woodpecker family has been steadily moving north and is now a common sight in the New York metropolitan area in all seasons. Subsisting mostly on insects, the Red-bellied Woodpecker also feeds on fruits and berries and, occasionally, on tree frogs and small eggs. Their bright red heads may lead some observers to misidentify them as Red-headed Woodpeckers, but that species has a black body and is much rarer in the New York area. Besides its bright red cap, the Red-bellied Woodpecker has a striking variegated black-and-white back and a slight reddish tint on its undersides (if seen close-up). There is no mistaking the call of this woodpecker; it is easily identified by its relatively loud "kwirr" and also by its loud hammering on tree trunks as it looks for food or hollows out a hole for a nest. In this photograph, a Red-bellied Woodpecker is looking for insects in the limb of a dead tree in the Ravine in Central Park.

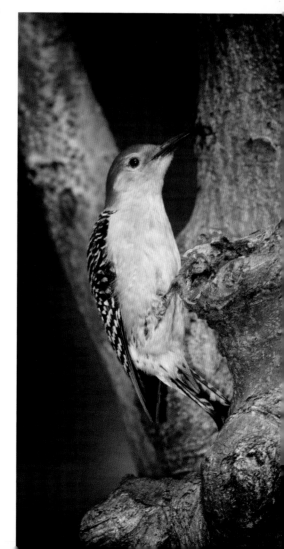

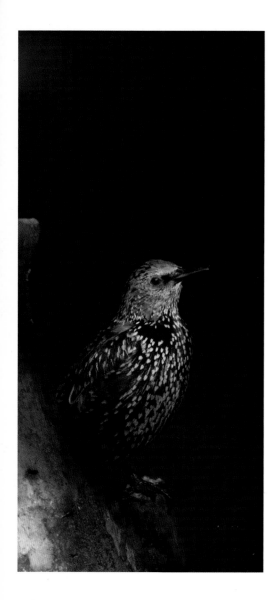

European Starling

European Starlings (known as just "starlings" in Europe) were introduced into the United States by a group in New York City. In the late nineteenth century, after failing twice at introducing the birds, the American Acclimatization Society, headed by Eugene Schieffelin, introduced sixty starlings into Central Park. From that small flock, American Starlings grew to be the most common songbird species in North America, with a population estimated to be more than 150 million birds. Many view European Starlings as a pest, as they have adapted easily to urban environments. New York City has a very large population of European Starlings that can be seen in parks and on sidewalks throughout the city. Their distinctive shiny black coloring, stippled with light brown, makes them easy to spot. They are ground feeders, but also like fruit. The male is a supreme mimic and in urban settings may imitate sirens, car horns, and other birds. They are cavity nesters, although they don't create the cavities. I have seen woodpeckers and starlings fight for a hole in a tree that the woodpecker has created, only to have it claimed by a European Starling. This bird was photographed in the early morning at the Hallett Nature Sanctuary in Central Park.

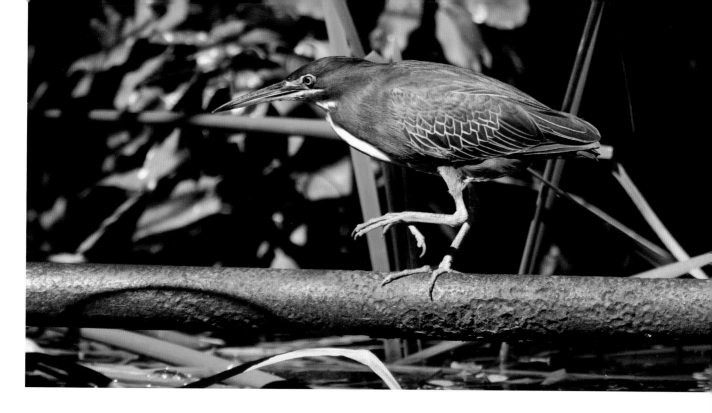

Green Heron

The Green Heron is one of the smallest members of the family that includes egrets and bitterns. From a distance, the Green Heron seems like a dark, chunky bird, but seen up close, its yellow eyes and legs, combined with a chestnut face and dark green back, make a striking impression. The Green Heron further shatters the impression of clunkiness when it extends its neck to full height, making it appear almost twice its previous size. Green Herons eat small fish, aquatic insects, and small crustaceans. They stand rigidly still at water's edge waiting for prey to swim into view, then quickly pounce. Green Herons have been observed capturing insects, then letting them loose in the water to attract fish in one of the few known instances of birds using tools. The bird in this photo is stalking prey while walking along a metal barrier in Central Park's Harlem Meer.

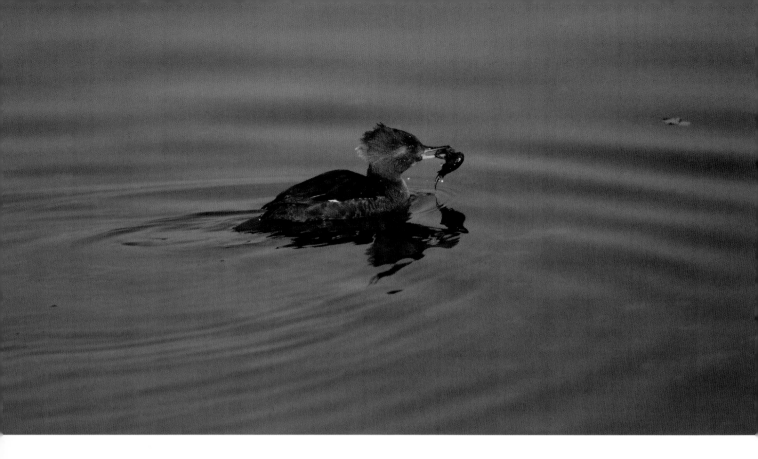

Hooded Merganser

Male and female Hooded Mergansers are strikingly different. The male has distinct black-and-white patterns with buff-colored flanks, while the female is variegated shades of brown. Both have a "hood" that is displayed when they are agitated. Mergansers are one of the few duck species that eat fish. They survive on a diet of crayfish, small fish, and other aquatic animals. They are abundant in our area and overwinter if there is a sufficient food supply. One of the best places to observe Hooded Mergansers in the winter is on the Reservoir in Central Park, where there is an abundant supply of crayfish and small fish. In this photo, a female Hooded Merganser is swimming on the Reservoir with a crayfish in her serrated bill.

Eastern Bluebird

The Eastern Bluebird is the state bird of New York, and the bright blue-headed male is a common sight along country roads in open fields throughout the state. As its name implies, the Eastern Bluebird is found east of the Rockies and as far north as southern Canada. While they breed in New England and the northern Midwest, the Eastern Bluebird is found year-round in the southeastern United States. The female has a dull blue-gray head and rusty undersides. While they feed extensively on insects, they also eat fruits and berries. This Eastern Bluebird was photographed in the Wildflower Meadow in Central Park, attracted by the abundance of Oriental bittersweet berries. Birds have helped spread this invasive plant throughout the eastern United States, and the last of these berry plants was only recently removed from Central Park.

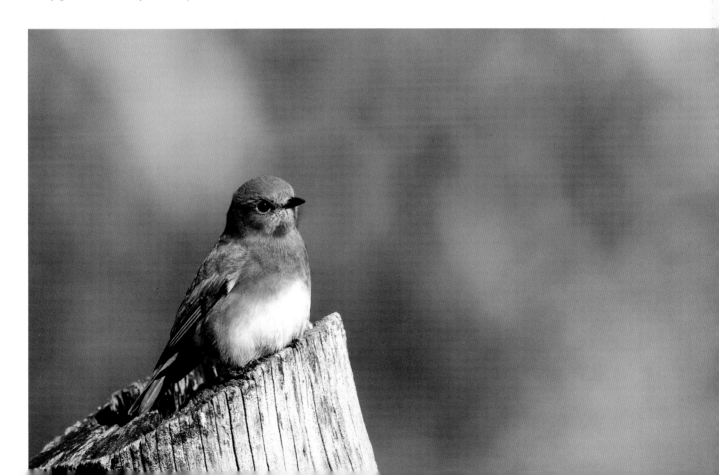

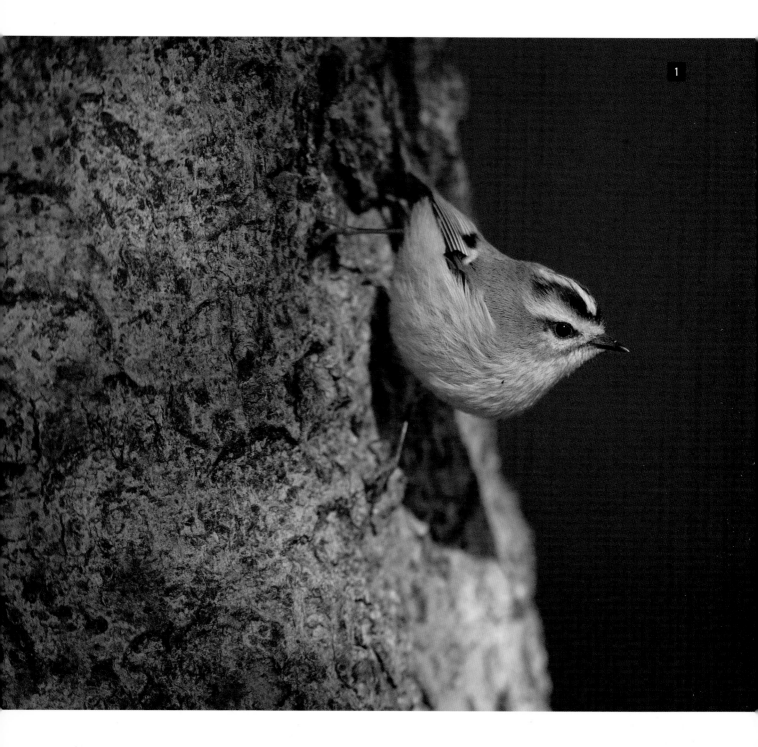

Golden-crowned Kinglet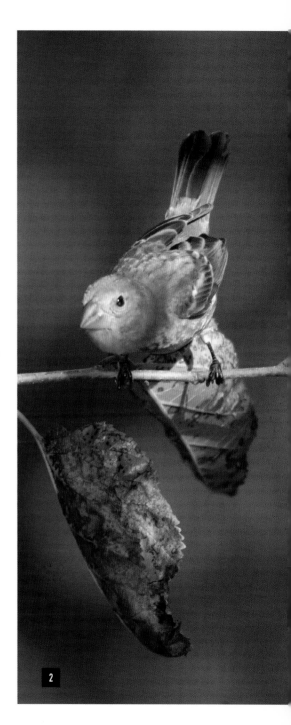

The Golden-crowned Kinglet is one of the smallest of North American birds, only slightly larger than a hummingbird. Named for the lemon-yellow "crown" on its head, the Golden-crowned Kinglet breeds in coniferous forests in the United States and Canada. It has a remarkable ability to survive cold temperatures that allows these birds to delay migration into the winter months. The "golden crown" is sometimes hard to spot, but when the bird is agitated it raises it, and there is no mistaking those bright yellow feathers tinged with orange. There are year-round populations along the East and West Coasts and in the Rockies and Appalachians. Birds nesting in Canadian forests migrate south in the fall and winter and can be found in fairly large numbers in most states during the winter months. During spring and fall migration, Golden-crowned Kinglets are a common sight in the New York metropolitan area.

Blue Grosbeak

Although typically a bird of the southern United States, Blue Grosbeaks have been found to breed as far north as New Jersey and winter as far south as Mexico, Central America, and the Caribbean. They are chunky birds with large bills—in fact, the word "grosbeak" is from the French "grosbec," which means "large beak." The male in breeding plumage is a deep blue, while the female is cinnamon-colored year-round. Immature males resemble females, making the identification of this particular bird problematic. Both males and females have large silver bills ideal for cracking seeds, although they feed on insects as well. This bird was photographed in the Wildflower Meadow in Central Park. This bird—or a very similar one—was seen every fall in the Wildflower Meadow for several years in a row.

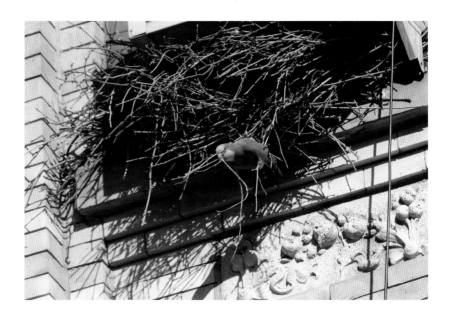

Monk Parakeet

Although Monk Parakeets (also known as Quaker Parrots) are native to Argentina, they have managed to establish colonies in the New York metropolitan area and other places in the Northeast. Urban legend says the first Monk Parakeets escaped from shipping crates at Kennedy Airport, but they are more likely descendants of parakeets sold as pets in the 1970s in many major cities around the world. In addition to New York City, colonies of Monk Parakeets can be found in Connecticut, Rhode Island, Chicago, Wisconsin, and several cities in other countries. Monk Parakeet nests are found throughout the metropolitan area, with the largest colony nesting at Greenwood Cemetery in Brooklyn. These loud, brightly colored birds construct large nests with twigs they gather from nearby trees. Their beaks are like pruning shears; in the accompanying photo, a Monk Parakeet is seen snapping off a small branch to secure a twig for a nest it is building under an air conditioner on West 103rd Street.

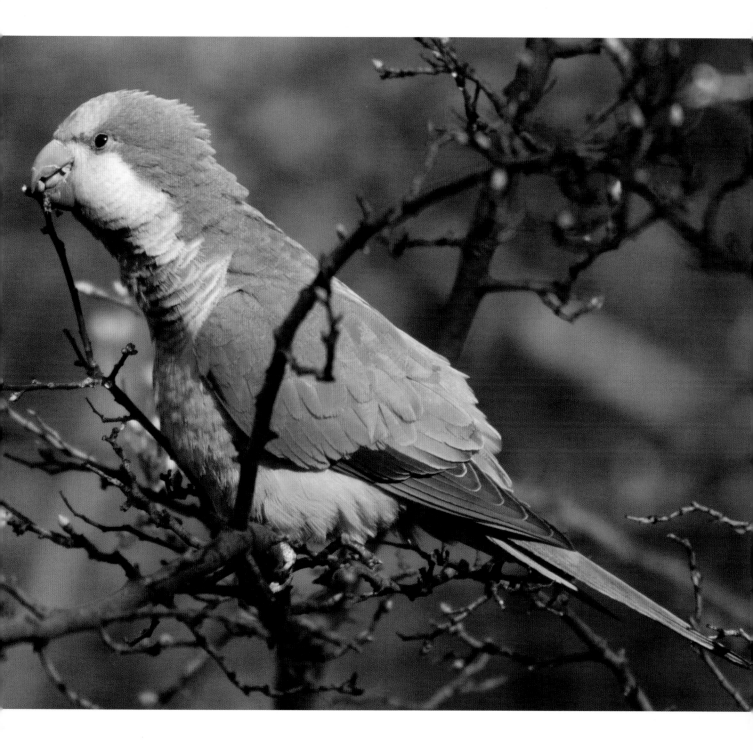

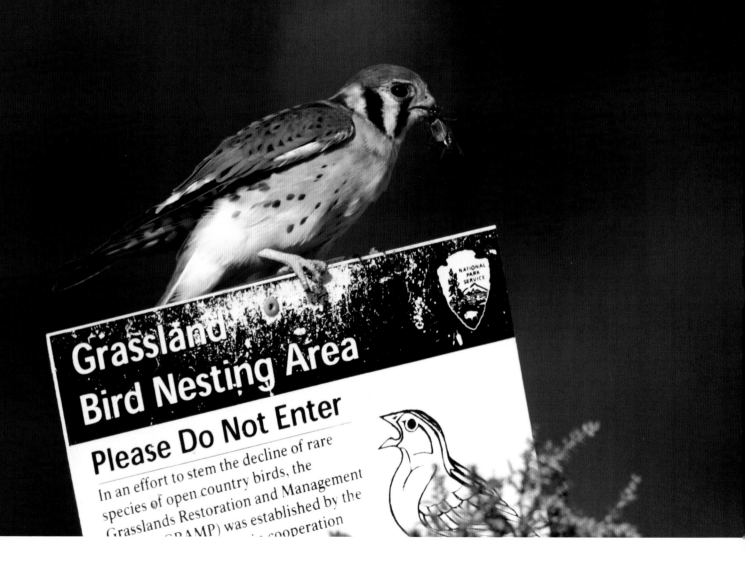

Grassland
Bird Nesting Area

Please Do Not Enter

In an effort to stem the decline of rare
species of open country birds, the
Grasslands Restoration and Management
(GRAMP) was established by the
in cooperation

American Kestrel

The American Kestrel is the smallest of North American falcons and one of the most commonly seen in the country and city. They are year-round residents whose characteristic "waweep-waweep-waweep" calls make them easy to find. They prefer to hunt for insects or small mammals from high perches, so urban environments, with their abundance of rats and mice, make excellent hunting and breeding grounds for this colorful raptor. Although the American Kestrel seems to be on the decline in open areas where pesticides have killed their food source, they seem to be moving into urban areas in large numbers. There is a resident Kestrel on Broadway on the Upper West Side of Manhattan that can be seeing on a high perch overlooking the buildings in the area. I have also observed a Kestrel nest in a rusting tin cornice on the Lower East Side of Manhattan. The slate-blue wings on the bird in this photograph indicate a male. The female has reddish-brown wings, and both male and female have black vertical stripes on the sides of their faces. This male American Kestrel has an insect in his beak and is perched on a sign at Floyd Bennett Field in Brooklyn. Floyd Bennett Field was New York City's first municipal airport and later became a naval air station. Now large parts are restricted, and the grasslands inside the fenced areas are home to many endangered species of grassland birds. The abundance of insects attracts the Kestrels, and they are a common sight perched on fences and signage there.

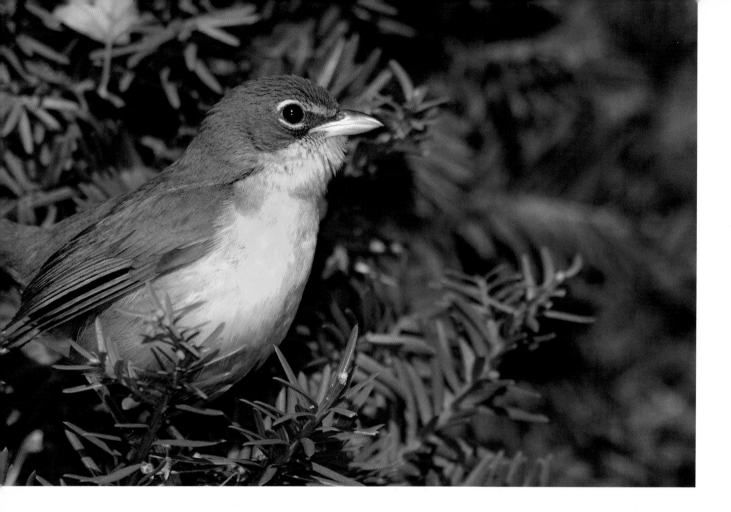

Yellow-breasted Chat

The Yellow-breasted Chat is widespread across the United States, but is hard to find as it is a "skulker" that prefers thick, dense underbrush. Although it has not spread extensively into New England, the Yellow-breasted Chat is being seen more and more in lower New York State. It is the largest North American warbler and breeds in just about every state in the Continental United States. The Yellow-breasted Chat winters in southern Mexico and Central America. Both male and female make a variety of calls (some quite bizarre), and the species has some-

times been called the "mockingbird of warblers." Their bright yellow breasts give them their name, and they can also be identified by a distinctive white eye ring. When Yellow-breasted Chats are seen in the New York metropolitan area, it is often during the fall. The bird in this photograph was seen for more than a month at Bryant Park in Manhattan. The same individual, or a similar bird, has been seen over multiple years in that same location.

Northern Mockingbird

The Northern Mockingbird gets its name from its unique ability to copy or "mock" sounds it hears. In addition to being able to copy other birds' calls, the Northern Mockingbird has been observed mimicking car alarms, squeaky wheels, and police sirens. They are also a popular cultural symbol, with five states adopting the bird as their state bird. A very intelligent bird, the Northern Mockingbird was captured and kept as a pet from the 1700s through the early part of the twentieth century, mostly in the eastern United States. Very loud and aggressive, Northern Mockingbirds sing almost constantly during daylight hours and have been known to attack cats and other small mammals that venture too close to their nests. Both males and females are a dull brownish-gray with white patches on each wing. They feed on insects, fruits, and berries, and nest in the same location year after year. This Northern Mockingbird was photographed feeding on ripe berries in Central Park.

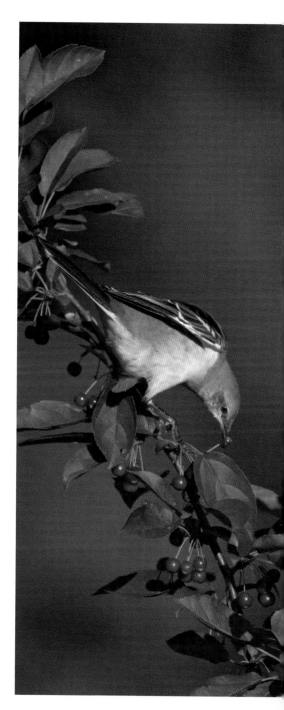

Saltmarsh Sparrow

The Saltmarsh Sparrow (formerly called the Saltmarsh Sharp-tailed Sparrow) is a small American sparrow of eastern salt marshes that, along with several related species, has spiky tips on its tail feathers. It was thought, until recent genetic testing proved otherwise, that the Nelson's and Saltmarsh Sparrows were the same species. Since that discovery the "sharp-tailed" has been officially dropped from their names and the two species were rechristened Saltmarsh and Nelson's Sparrows. In the spring, the Saltmarsh Sparrow builds its nest in salt marshes just above the high-tide line from Virginia through Maine. In the fall, they migrate south, wintering across a range that extends from Virginia through Florida. They are small, quiet sparrows that exhibit unusual breeding habits. Unlike other songbirds, Saltmarsh Sparrows do not defend their breeding territory and do not form pair bonds. Males will fly around the marsh looking for females to mate with and take no part in raising the young. This secretive bird is difficult to find; I was lucky to run across the specimen in this photo at Plumb Beach off the Belt Parkway in Brooklyn.

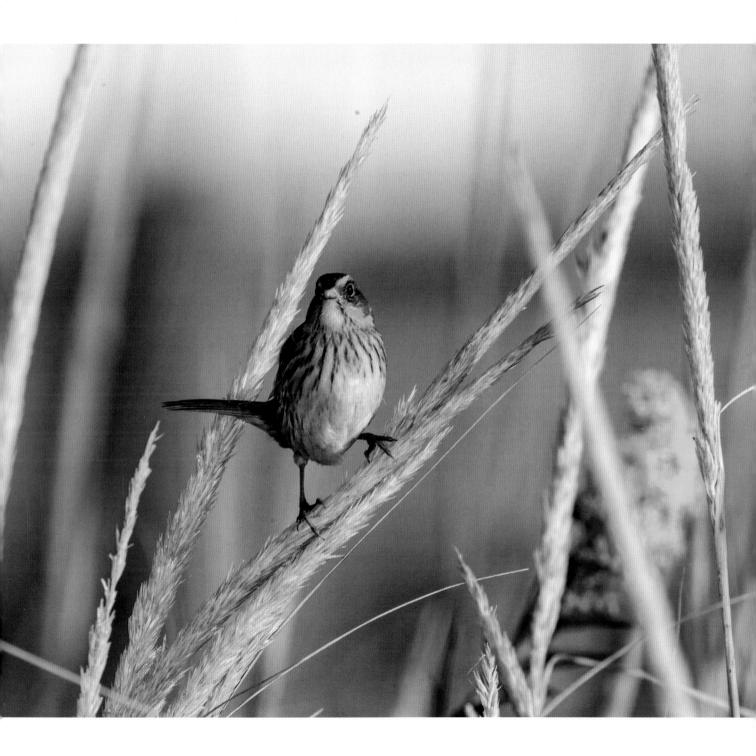

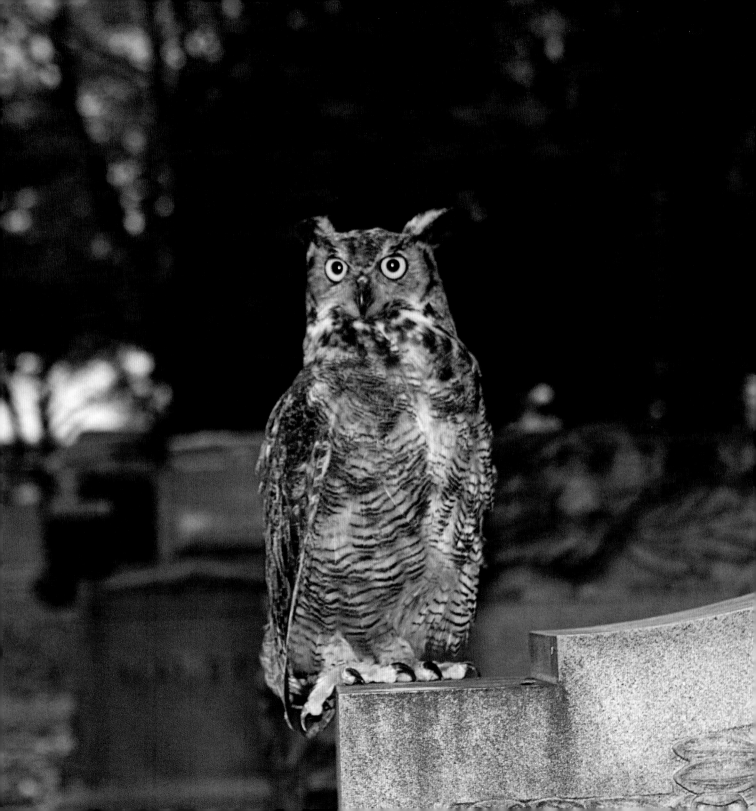

Great Horned Owl

In addition to being one of the largest owls in North America, the Great Horned Owl is also one of the most common. It is highly adaptable and is at home in forests and open country as well as in deserts and urban environments. Great Horned Owls in the North begin nesting in late winter. They are not migratory, and often a pair will spend their entire lives in one territory, nesting in dead trees and other cavities. Great Horned Owls feed on small mammals—including mice, squirrels, and rabbits—and also on other birds, including ducks and other smaller owls. Many parks and large cemeteries in New York City play host to nesting Great Horned Owls. This shot shows a Great Horned Owl sitting on a tombstone in Woodlawn Cemetery, adjacent to Van Cortland Park in the Bronx. The bird was found severely injured there and was nursed back to health by the Wild Bird Fund before being released in the same location where it was found. This shot was taken immediately after the bird's release. There are also nesting Great Horned Owls on Hunter's Island in the Bronx and Alley Pond Park in Queens, as well as several other city parks.

Rock Pigeon

Known previously as the "Rock Dove," in 2011 the International Ornithologists' Union settled on Rock Pigeon as the name of this ubiquitous species. Originally from Europe and the Middle East, pigeons arrived in the New World in 1600 and gradually spread to blanket both North and South America. A highly adaptable species, pigeons find urban environments much to their liking and can be found in every city in the country. A favorite meal of Peregrine Falcons, the rise of pigeons in urban environments has also led to an increase in Peregrine Falcon populations in larger cities, a welcome change after the falcon's disastrous decline in the 1970s as a result of the indiscriminate use of agricultural pesticides. They are also comfortable in the wild and can be found nesting in cliffs far from urban sprawl. Humans have used pigeons for racing, delivering messages, in scientific research, and as food. Pigeons like the company of other pigeons and can be found in flocks throughout New York City. They come in many color variations, with the most common being the blue-gray version that features striking iridescent feathers on the head and neck. The birds in this photograph (darker male and lighter female) are doing what is called "courtship feeding." It is ritualized behavior that does not involve actual food, but serves to cement the bond between the male and female, which mate for life.

Belted Kingfisher

Kingfishers are short, stocky birds with large heads and thick bills. Below its blue neck stripe, the female has a rufous chest stripe that is lacking in the male. Belted Kingfishers eat mainly fish and other small aquatic animals. They are found in coastal areas as well as near lakes, streams, marshes—basically anywhere a marine food source is available. They are a noisy bird, and their loud rattle is easy to identify. They are migratory and can be found as far north as the Alaskan tundra and Canada's Hudson Bay in the summer and down as far as the southern United States, Mexico, and Central America in winter. They will also remain in areas where ponds and streams do not freeze over in winter. The bird is so common in Canada that it was featured on the 1986 version of the five-dollar Canadian note. Belted Kingfishers can be found perched on high snags over water, searching for prey. From this perch, they fly down into the water and capture small fish in their long beaks. A rare visitor to Central Park, this Belted Kingfisher was photographed in the Ravine.

Black-throated Blue Warbler

The male Black-throated Blue Warbler has a striking slate-blue head and back with a black face and black stripe above a white breast. The female, by contrast, is a dull olive color with a light yellowish breast and a white wing patch. Black-throated Blues breed in eastern deciduous forests of the northern United States and southern Canada, and winter in the dense tropical forests of the Caribbean and Central America. They are rarely seen west of the Mississippi. Most pairs form a bond that keeps them together during nesting season year after year, although the male may breed with more than one female. Black-throated Blue Warblers are insectivores. During migration, it is easy to spot them in the New York City area because they tend to work one particular area looking for insects, unlike other warblers that move quickly from tree to tree as they feed.

Ring-billed Gull

This first-winter Ring-billed Gull has been treated with a pink dye, presumably as part of a scientific study. Typically, gulls are dyed to make their movements easier to track by ornithologists studying migration and movement patterns. Ring-billed Gulls are one of the most numerous species of gulls in North America, frequently seen around landfills, parking lots, golf courses, and freshly plowed fields. Most Ring-billed Gulls nest inland near freshwater sources and move south during the fall to the southern United States, Mexico, and the Caribbean. Many pass the winter along both East and West Coasts, and can be found in large flocks in parking lots along beaches, scavaging at landfills, and foraging near restaurants. Ring-billed Gulls are omnivorous and will eat just about anything, making them perfectly adapted to coexist with human populations. As the bird matures, the black tip on its beak recedes, giving the bird its eponymous "ringed" bill. This bird was photographed floating on the Harlem Meer in Central Park and was not seen again after that initial sighting. In winter, large numbers of Ring-billed Gulls can be found in and around freshwater lakes and ponds in New York City's parks.

Gadwall

The Gadwall is known as a "dabbling duck" because it submerges its head underwater to feed on aquatic plants, sometimes completely upending itself so only the tail is visible. Although lacking the brightly colored patches that characterize the males of other duck species, the Gadwall is nonetheless striking with its intricate patterns of gray, brown, and black. They are about the same size as Mallards, and both male and female have a white wing patch that is visible in flight. Widespread throughout the United States and Canada, some Gadwalls migrate as far south as Mexico in the winter, while others remain year-round residents along the East Coast or in Southern California. Gadwalls are seen in the New York metropolitan area mostly in the winter. This male Gadwall was photographed on the Harlem Meer in Central Park in December.

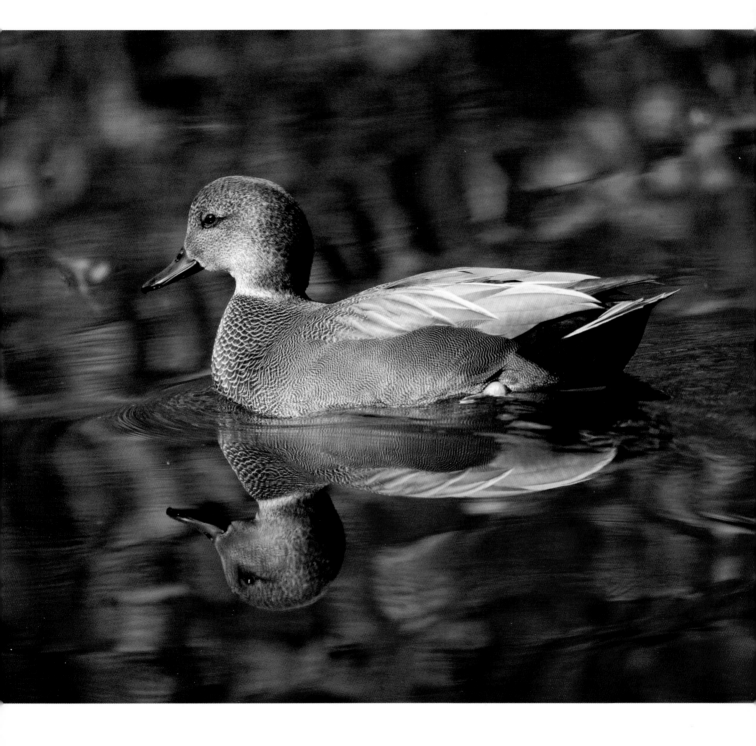

WINTER

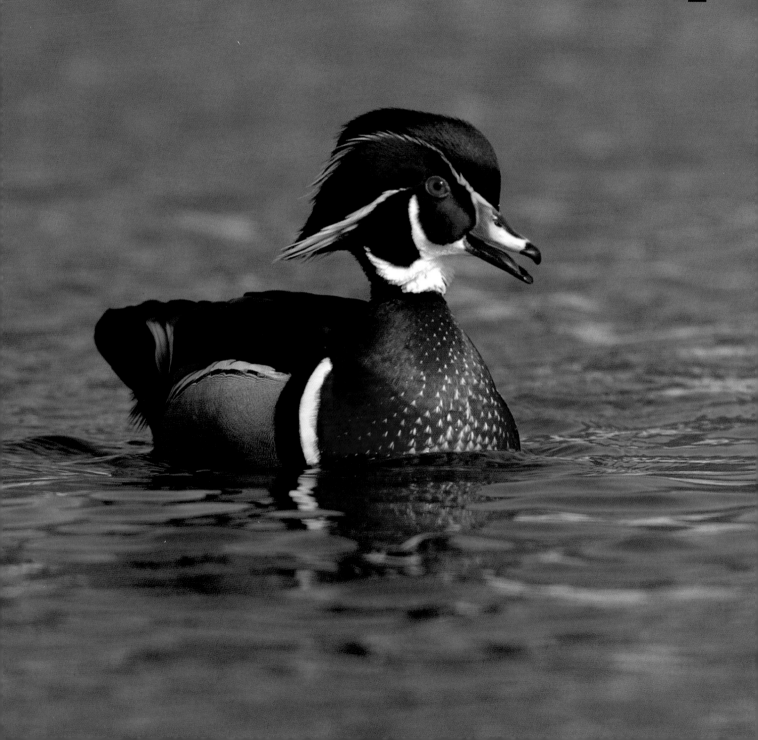

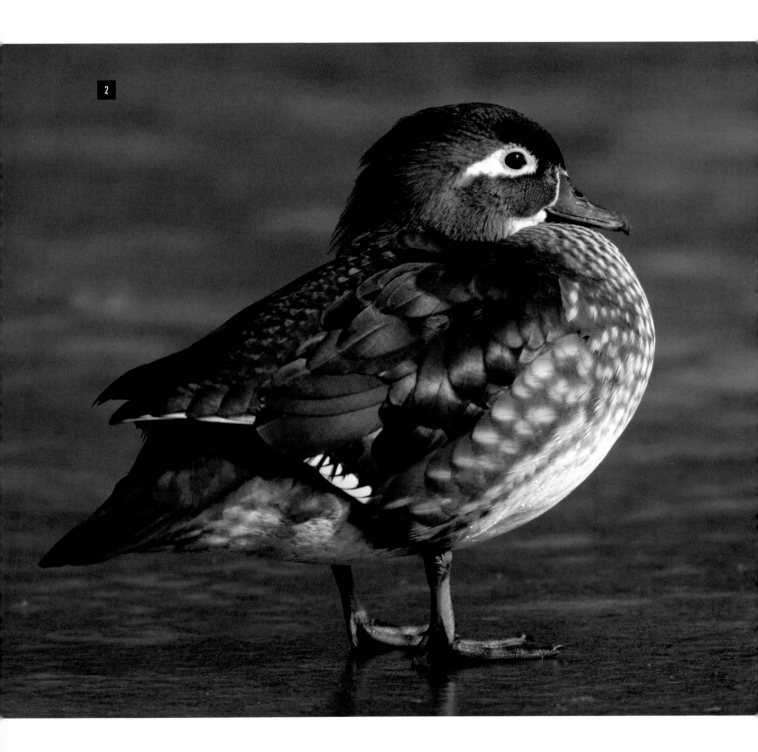

Wood Duck 1 2

The male Wood Duck is the "fashionista" of North American ducks with its iridescent green head, red eyes, chestnut-colored breast dappled in white, and yellow ocher flanks. Wood Ducks are one of the few duck species with claws, which they use to grip tree branches and climb bark. Wood Ducks nest in tree cavities near water in swamps, small lakes, and marshes, so having claws helps them access their nests. When the ducklings are ready to leave the nest, they jump out of the hole in the tree down into the water below and immediately start swimming. Wood Ducks breed throughout most coastal areas of the United States and Canada, with northern populations moving as far south as southern Mexico in winter. Although Wood Ducks nest in New Jersey, they are not often seen in the New York metropolitan area except during winter months. This male Wood Duck was photographed on Central Park Lake in December.

The female Wood Duck has an understated elegance that is in sharp contrast to the gaudy male. Female Wood Ducks are mostly gray and brown with a mottled breast and yellow eye ring. In normal light they appear dull, but when the sun strikes their wing feathers at the right angle, they glow with a stunning iridescence, as seen in this photograph taken on Central Park Lake. Wood Ducks are not seen in large numbers in the Northeast in winter. The northern ducks usually move farther south during the winter months to join permanent populations in the Gulf area and along the Pacific coast. Wood Ducks nest in cavities in trees near or overhanging water. One day after the ducklings hatch, they jump from the nest and begin swimming. At the end of the nineteenth century, Wood Duck numbers were in steep decline as a result of hunting and the millinery trade. Habitat loss also contributed to this decline. However, after the Migratory Bird Treaty was passed in 1918, unregulated hunting was banned. Also by then, exotic plumage was no longer in fashion and birds were not hunted for their feathers in great numbers. Wood Ducks are still taken during duck-hunting season, but the number of birds that can be taken by each hunter is strictly limited.

White-breasted Nuthatch

The White-breasted Nuthatch is a common year-round sight in most of the continental United States and southern Canada. White-breasted Nuthatches are common feeder birds that are attracted to sunflower seeds and peanuts. The White-breasted Nuthatch is the largest of the North American nuthatch species; it is still a small bird compared to many other species. It has a large head and short neck, and is the only nuthatch found in North America with a white face. The backs of their heads are black, and their backs are a slate gray. Although White-breasted Nuthatches eat seeds in winter, they are mainly insectivores and forage up and down tree trunks and on tree limbs in search of prey during the rest of the seasons. In this photo, the nuthatch is holding in its beak a peanut that it just retrieved from a feeder in the Ramble in Central Park.

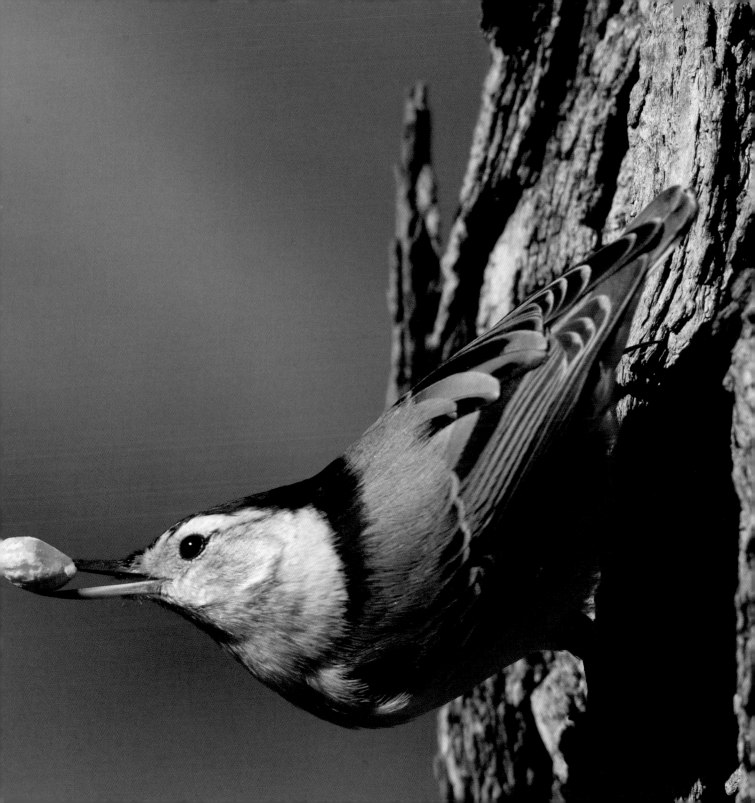

Brown Creeper

Brown Creepers are tiny birds whose mottled brown backs provide almost perfect camouflage against the tree bark that they scour for insects and insect eggs missed by other birds. Their curved bills are perfect for digging out their food from crevices in tree bark. They constantly move up and down trunks of large trees searching for food. When they get to the top of one tree they will flutter down to the base of the next and begin again, spiraling around the tree as they move toward the top. If a predator enters the area, they freeze and become almost invisible against the rough brown tree bark until the threat moves away. One of the best ways to get a look at a Brown Creeper is from the side, since their white bellies stand out against dark tree bark. They are fairly common most of the year in the northern United States and southern Canada and along the West Coast through southern Alaska. Birds that breed farther north will move south for the winter. Brown Creepers are found year-round in the deciduous forests of both the Rocky and Appalachian mountain ranges. The bird in this photo is digging for insects in tree bark in the north end of Central Park.

Common Redpoll

The Common Redpoll is a small finch that breeds on the Arctic tundra and is only a partial migrant, driven south in winter not by the cold but by of a lack of food. During years when food is scarce, irruptions of Common Redpolls can be seen as far south as the central United States, where they are a common sight at bird feeders. They are mostly brown and white, with streaking on their sides and a red patch on their heads. Males have a pale raspberry-red chest and flanks. Common Redpolls travel in flocks that constantly seem on the move while foraging for seeds on the ground and in trees. Their small, stubby bills are ideal for

cracking seeds. The male Common Redpoll in this shot was trying to pry seeds from a sweetgum pod in Central Park, so he stayed in one place long enough to get a picture. He was part of a flock of about fifteen other redpolls.

Sharp-shinned Hawk ▮1

Sharp-shinned Hawks are the smallest of all the North American hawks. In summer, they nest across most of Canada south of the Arctic Circle and are year-round residents in the Northeast and mountainous West. In the fall, northern populations of Sharp-shinned Hawks migrate as far south as Mexico. Great numbers of hawks (called kettles) can be seen flying south over New Jersey in the fall. The Cape May Observatory has reported as many as 10,000 Sharp-shinned Hawks flying overhead in one day in late fall. The Sharp-shinned Hawk's diet consists almost exclusively of small birds. Unlike owls, they pluck the feathers from their prey before eating. Sharp-shinned Hawks are not typically seen in urban areas, except during migration. This bird was photographed in the Ramble in Central Park.

Red-headed Woodpecker ▮2

Red-headed Woodpeckers are birds found in the deciduous forests of southeastern Canada, as well as the northeast and midwestern United States. Some birds that nest in Canada and the Northeast migrate south for the winter, but not very far. The Red-headed Woodpecker has been in decline in recent years, likely as a result of habitat loss and shrinking food supplies. Red-headed Woodpeckers eat larvae and insects they dig out of tree bark. Also, unlike other woodpeckers, they can catch insects in-flight. They also feed on nuts and berries, and will stash acorns in tree cavities for later. Red-headed Woodpeckers take at least a year to acquire their bright red heads. The bird in this photo, seen stashing an acorn in a tree cavity, is just entering his second year and acquiring his red head. This is one of the rare Red-headed Woodpeckers seen overwintering in our area in Riverside Park on the West Side of Manhattan.

Downy Woodpecker

The Downy Woodpecker is the smallest and most common of wood-peckers. It is found year-round throughout the United States and Canada; about the only place you won't see it is in arid areas of the Southwest. It eats mostly insects, but will also eat seeds and suet. Downy Woodpeckers make lots of noise both by drumming on trees in search of insects and with their shrill calls. The Downy Woodpecker in this photo is confronting a House Sparrow over a bit of suet on a tree branch in Central Park.

Yellow-bellied Sapsucker

The Yellow-bellied Sapsucker sounds like the name of a cartoon bird, but it is, indeed, an actual species of woodpecker. Nesting across most of Canada and the northeastern and the midwestern United States, it is one of the most migratory of all woodpeckers; there is no overlap between its summer and winter quarters. Summers are spent breeding across most of Canada, and winters are spent in the Southeast, Mexico, and the Caribbean. Females migrate farther south than males by a ratio of three to one. The New York metropolitan area is as far north as the Yellow-bellied Sapsucker will winter. The Yellow-bellied Sapsucker feeds on insects that are attracted to "sap wells" the woodpecker creates in certain species of trees. Sapsuckers drill neatly spaced holes in trees that allow sap to ooze out, and will fly from tree to tree eating the insects that are trapped in the sap. The Yellow-bellied Sapsucker has a special tongue designed to lap up the sap and any insects stuck in it. Too many sap wells can mean death for a tree, so Yellow-bellied Sapsuckers are sometimes treated as pests, especially in areas where there are orchards. The male Yellow-bellied Sapsucker has a bright red crown and a red throat. Females lack the red throat. The yellow belly is often hard to see, but it is visible in this photo of a female that is acquiring her winter plumage.

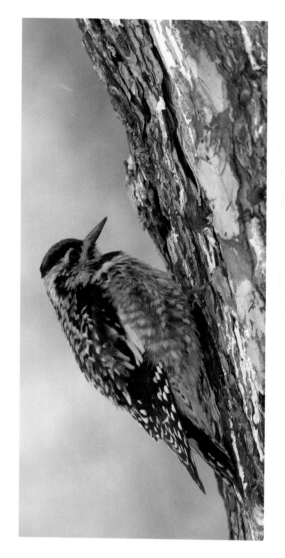

Northern Cardinal

Northern Cardinals can be seen throughout the eastern United States and Mexico. Cardinals don't migrate, so they are easily seen in winter when the male's bright red color stands out against the snow. They are so common and beloved that Northern Cardinals are the state bird of seven states. They are not commonly seen on the West Coast. However, they do breed in Arizona, where a baseball team carries their name. The male Northern Cardinal is bright red with a black face, while the female is a dull yellow with a reddish tail and wing feathers and an orange beak. She also has a black face. Northern Cardinals eat mostly seeds and are a common sight at feeders. They can also be found in backyards, parks, gardens, and other urban areas in close proximity to humans. In most songbird species only the male sings, but the female Northern Cardinal is the exception. Northern Cardinals are very common in the New York metropolitan area throughout the year, nesting in parks and other woodland areas. The male in this photograph was digging in the snow for seeds in Central Park.

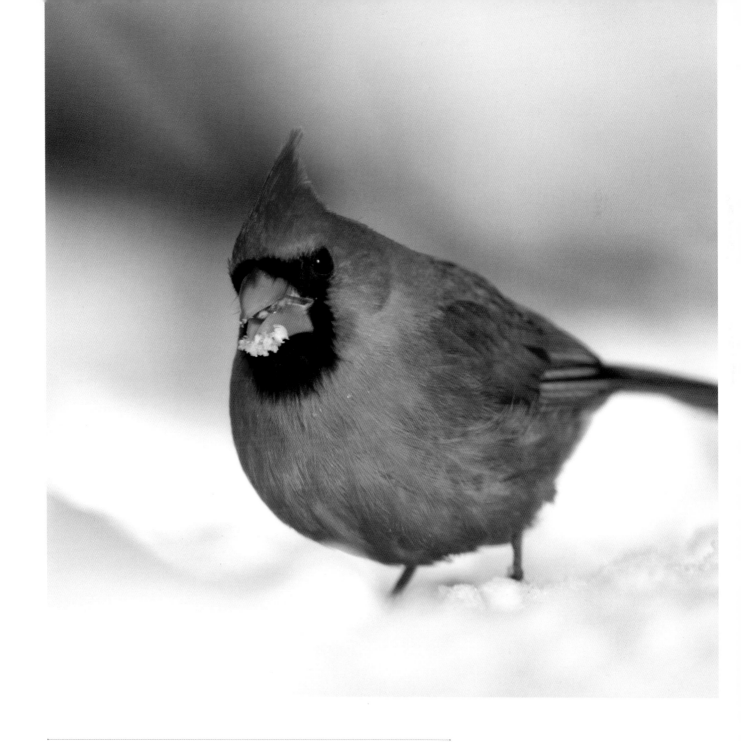

Cedar Waxwing

Whenever you see one Cedar Waxwing, there are bound to be others nearby. They travel in flocks and noisily descend on fruit-bearing trees. The Cedar Waxing is one of only a few Northern American species of birds that can survive on a diet of mostly fruit. If a Brown-headed Cowbird lays its egg in a Cedar Waxwing nest, the chick will usually die because it is unable to survive on a fruit diet. The "waxwing" in their name refers to the red waxy secretions on the tips of their secondary feathers. The "cedar" part is because the birds feed on cedar berries in winter. The tips of the Cedar Waxwing's tail feathers are bright yellow, except in cases where the juvenile bird has fed on a non-native species of honeysuckle; then they grow in with orange tips. There is no difference in size or coloration between male and female. Both have black "masks" around their eyes and a tuft of feathers on the tops of their heads. Their backs and necks are a buff brown. Their undersides are a similar color that lightens and turns yellow toward their tails. Cedar Waxwings are fond of crabapples and other ornamental fruits and berries that are commonly found in parks and urban gardens.

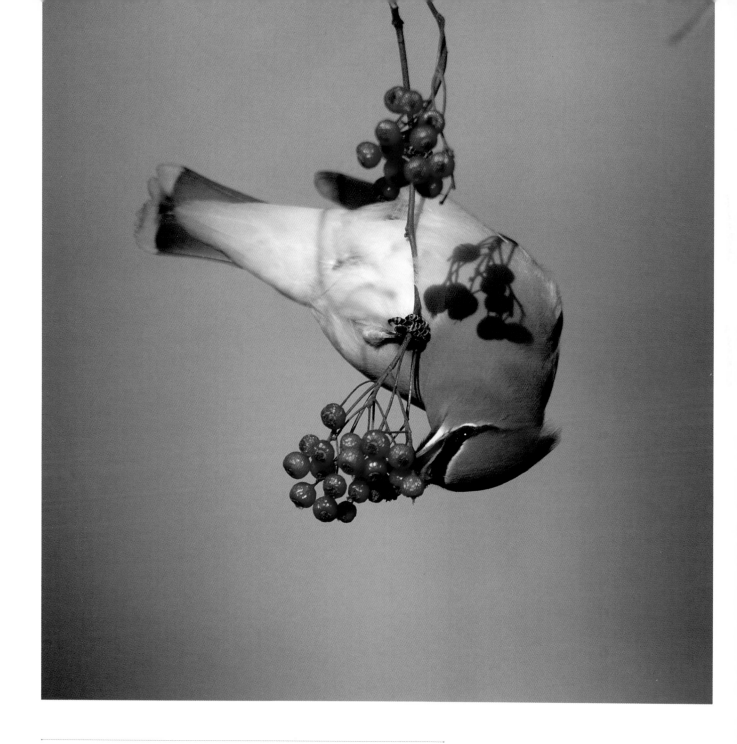

Red-breasted Merganser

The Red-breasted Merganser is a large diving duck with a long, thin, serrated bill. It is one of the few ducks that eats almost exclusively fish. The Red-breasted Merganser breeds across most of northern Canada and Eurasia. North American Mergansers winter along both coasts and down through the Gulf of Mexico as far south as Central America. It prefers saltwater, and in winter, great flocks gather in protected areas of the Northeast. The male Red-breasted Merganser has a speckled red chest with a white neck and an iridescent dark green head ending in a ragged crest. Because they dive for food, you often see them beating their wings (as seen in this photo) to dry them. Adult females are a rusty color, and both males and females have an orange-red beak. The Red-breasted Merganser owns the speed record for the fastest duck in the world, having been clocked at 100 mph while being chased by an airplane.

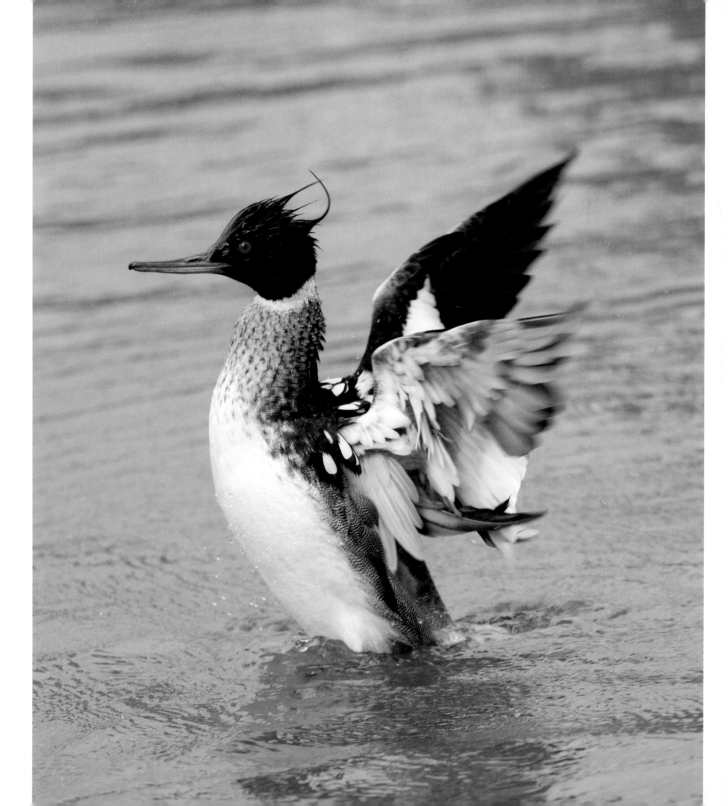

Northern Pintail

Northern Pintails are one of the most common species of ducks in the Northern Hemisphere second only to Mallards in numbers. They breed as far north as the Arctic Circle stretching across Canada, Russia, Siberia, and northern Europe, and as far south as the Great Plains of America. North American Pintails winter in the southern United States and Mexico. The male has a striking chocolate-brown head, a white neck and breast, and a gray-and-white checkered back and sides. Both sexes have blue bills and long, elegant necks. The bird's name comes from the male's long tail feathers. Northern Pintails are found in both fresh and saltwater, and in the Northeast are most commonly seen around marshes, mudflats, and flooded fields where they feed on aquatic plants, grain, seeds, and small crustaceans. The Northern Pintail is prized by hunters for its good eating and is hunted, in season, across its entire range. Although it is one of the most numerous species of waterfowl in the Northern Hemisphere, hunting, avian diseases, and the destruction of wetlands have led to the decline of Northern Pintails in the United States and Canada over the past several decades. The male Northern Pintail in this photograph spent most of the winter in Central Park.

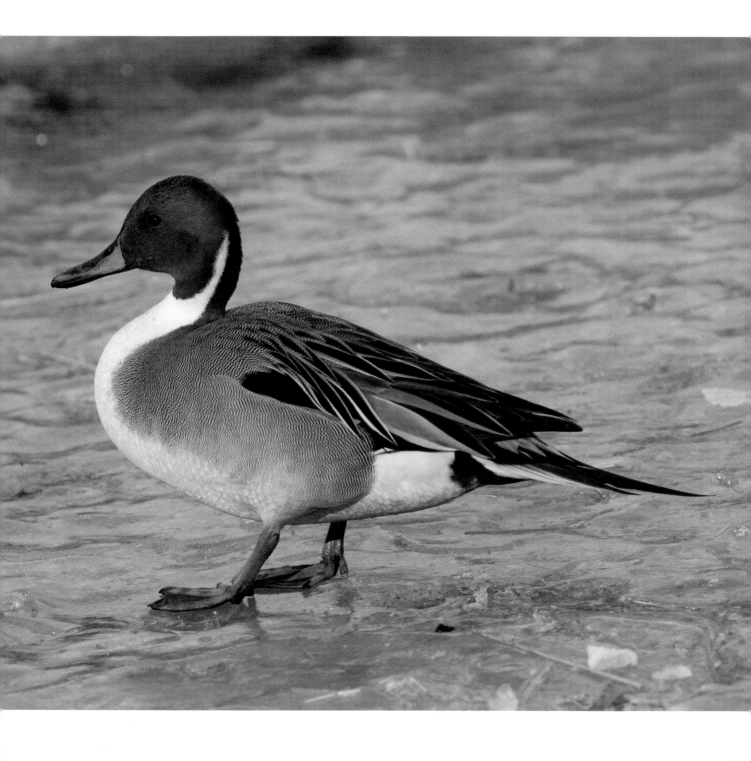

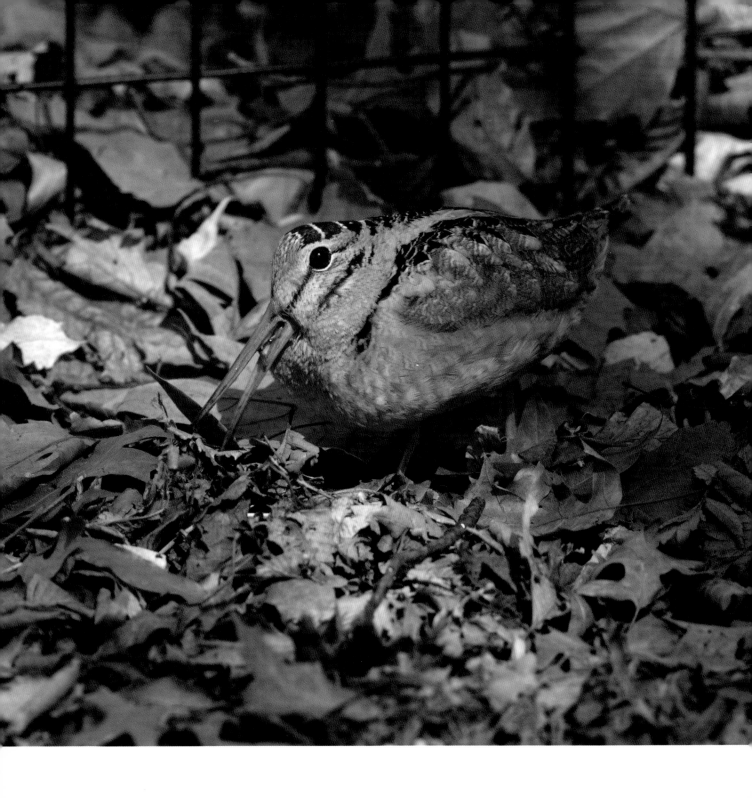

American Woodcock

American Woodcocks are shorebirds of the eastern United States, although they are not often found along shorelines but rather in upland areas and forest floors where their coloration makes them almost impossible to spot. To feed, they root through the leaf litter with their long bills, looking for earthworms and other insects. The American Woodcock's eyes are located high on its head, allowing the bird to watch for predators while it feeds. This short, plump bird is prized by hunters as a game bird, and more than a half million are killed annually during hunting season. American Woodcocks breed in the eastern United States as far west as the Mississippi and as far north as southern Canada. Northern breeders spend winters in the southern United States, migrating only at night to reach their wintering grounds. Male Woodcocks return to their nesting grounds in the Northeast in late February and early March, arriving several weeks before the female. The American Woodcock has a unique mating ritual where the male flies straight up into the air, often to heights of 250–300 feet, while emitting a "bzzzt" sound. He then flutters to the ground, making a series of bubbling, buzzing calls, and once on the ground he starts again. The bird in this photo is foraging in the leaf litter in the north end of Central Park in late February.

American Wigeon

The American Wigeon is a member of a group called "dabbling ducks," named after their behavior of feeding on aquatic plants near the surface of shallow ponds and wetlands and sometimes upending themselves to go after deeper plants. Unlike other dabbling ducks, American Wigeons spend a large amount of time in flocks on land, feeding on waste grain in harvested fields, clover, and winter wheat. They also spend more time in deeper waters than most dabbling ducks, usually in mixed flocks of coots and diving ducks, where they steal food brought to the surface by others. Males have a blue beak with a black tip and an iridescent green patch behind the eye that extends back to the nape of the neck. They also have a white patch on their heads extending from their bills to the crowns of their heads. The rest of the head is mottled with dark spots, and they have cinnamon-colored flanks and backs. American Wigeons breed in Alaska and western Canada and also in northern Plains states. They winter in the southern United States and along the East, West, and Gulf Coasts. Migrating American Wigeons are much more numerous along the Pacific Flyway than along the Atlantic Flyway. This bird is coming in for a landing off the coast of Hunter Island in the Bronx.

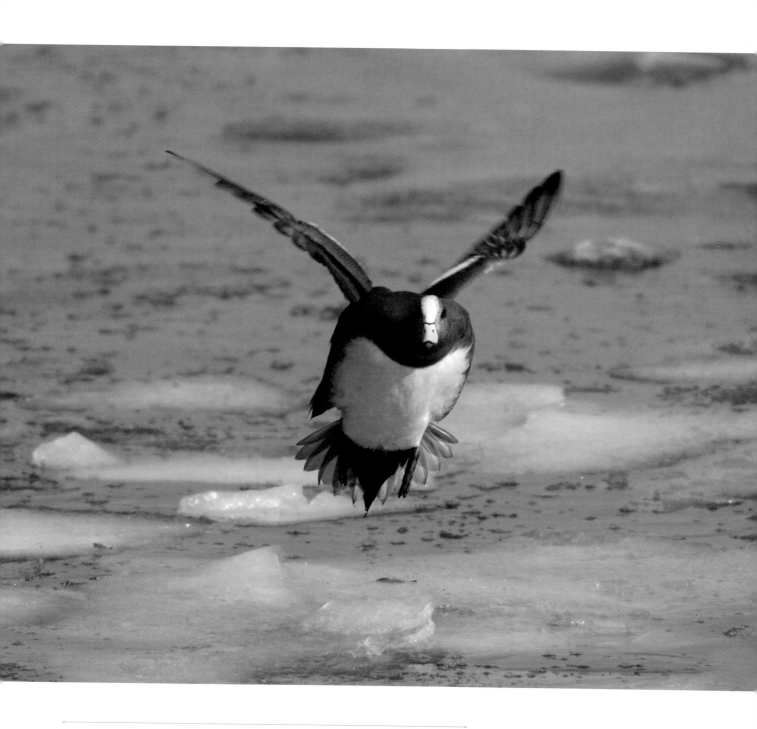

Red-tailed Hawk

Around ten years ago, a pair of Red-tailed Hawks (at least one an offspring of Pale Male, see page 9) built their nest on the statue of St. Andrew that adorns the eastern side of St. John the Divine on 110th Street in Manhattan. Since then, the pair have successfully fledged numerous offspring, usually two or three per year. The pair repairs and begins to occupy the nest in late winter and the chicks are ready to fledge in early June. In this shot, one chick remains in the nest waiting to attempt his first flight. During repairs to the façade, the nest was disturbed and the hawks built a new nest on the church not far from this one. There has also been a nest discovered at 116th Street and Riverside Drive, and another nest was recently found in J. Hood Wright Park in Washington Heights—both likely built by one of Pale Male's offspring.

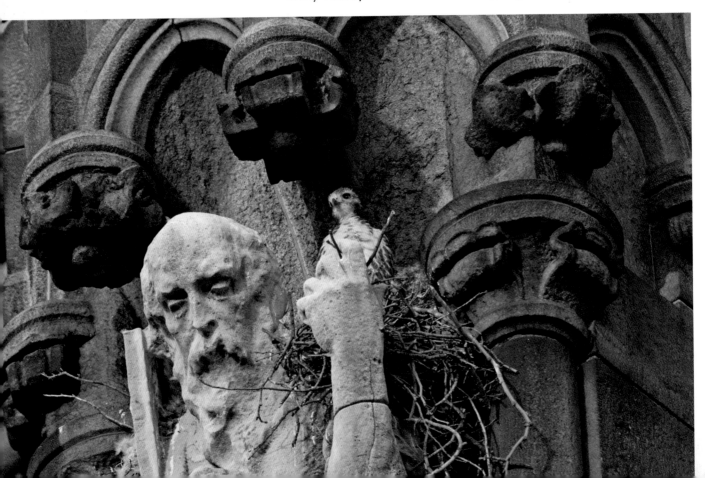

Boreal Owl

The Boreal Owl is an inhabitant of the boreal forests of northern Canada and Eurasia, so it was quite a surprise when one was spotted near Tavern on the Green in Central Park. Until the 1970s, it was thought this owl was only found in Canada, but continued sightings in upper elevations of the mountainous parts of the West confirm that the Boreal Owl breeds there as well. It is nocturnal, with excellent hearing well suited to finding prey under the snow. Its two ears are offset on either side of its head (one high and one low), so the Boreal Owl is able to judge distance and height by sound alone. Unlike most owls, the female is much larger than the male. The arrival of the Boreal Owl in Central Park caused an uproar in the birding community on the East Coast. People traveled great distances to see a bird that they had probably never seen in their lifetime. The owl cooperated by staying in the same area for about a week before it disappeared, never to be seen (or heard) again.

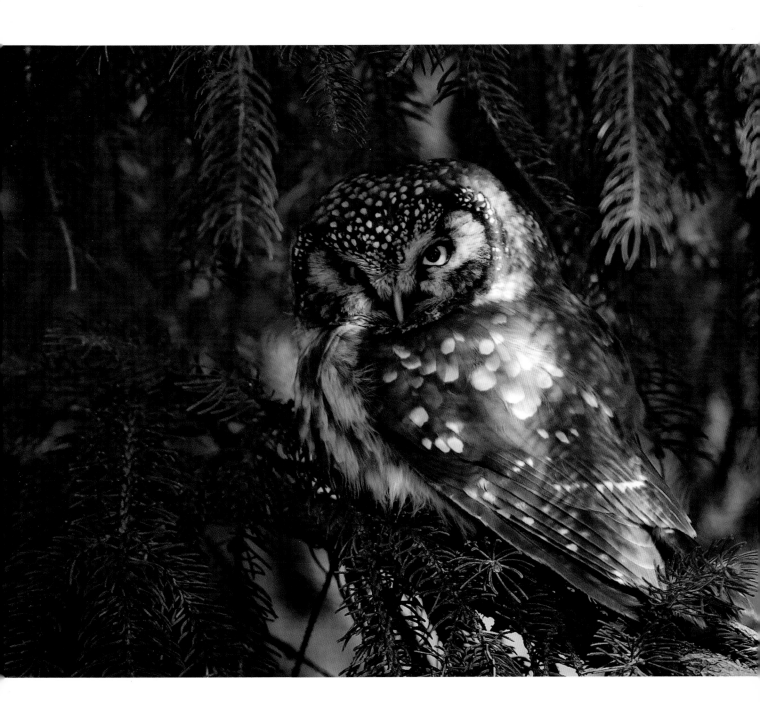

Long-eared Owl

Long-eared Owls breed in Europe and Asia as well as the United States and Canada. The so-called "ears" of the Long-eared Owl are not actually ears, but rather tufts of feathers that are located toward the center of its head, away from the actual location of their ears. Like many owls, Long-eared Owls eat their prey whole and regurgitate the inedible parts. One way to find roosting owls is to look at the base of a tree for these "pellets." Long-eared Owls are not an uncommon sight in our area in winter and are mostly seen roosting in dense pines, where their coloration provides near-perfect camouflage. The bird in this photo was roosting in a tree in Central Park with no less than three other Long-eared Owls. Every night, before they flew out to feed, a large crowd would gather under the tree where they roosted and await their fly-out. They seemed impervious to people, dogs, and photographers, and stayed for almost a month. Birders also waited eagerly to snatch their pellets almost as soon as they were regurgitated.

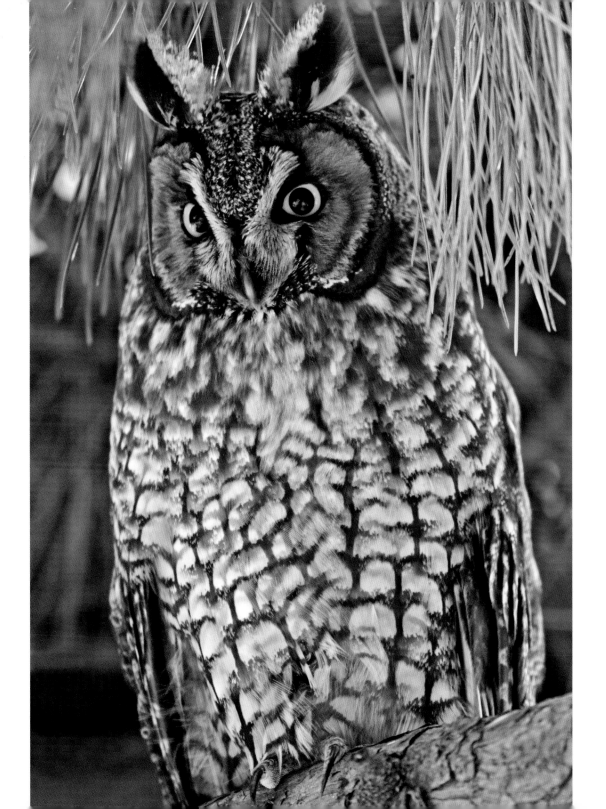

Rusty Blackbird 1

Rusty Blackbirds get their name from the rust-colored feathers on their heads, backs, and chests that they acquire during winter. The Rusty Blackbird is a close relative of the Red-headed Blackbird and Common Grackle, and breeds in spruce bogs across northern Canada. In winter, it migrates south to swampy areas in the southeastern United States. During migration, it can usually be found walking along streams looking for aquatic insects. Although it's difficult to determine because of their remote breeding grounds, most ornithologists agree the Rusty Blackbird has undergone a precipitous decline in the last few decades, losing about 5 percent of their population yearly since 1966. Scientists are at a loss to explain the decline, but they suspect habitat loss may contribute to the problem. This Rusty Blackbird was photographed walking beside a stream in Central Park.

Mourning Dove 2

Mourning Doves are one of the most numerous birds in North America. They are also the most hunted, with forty states allowing dove hunting within their state borders. New York State does not allow dove hunting, and it is also prohibited in Connecticut, Iowa, Maine, Massachusetts, Michigan, New Hampshire, New Jersey, Rhode Island, and Vermont. It is estimated that hunters take more than 20 million birds every year, but this doesn't seem to affect the overall population, which remains steady at more than 350 million birds. Mourning Doves are plump birds with long tails and are a light reddish-brown, with black spots on their bodies and black wingtips. They have short bills and legs, and fly straight and fast when disturbed. As year-round residents of the area, they don't seem to mind the snow as long as there are seeds available. Mourning Doves survive in desert climates because they

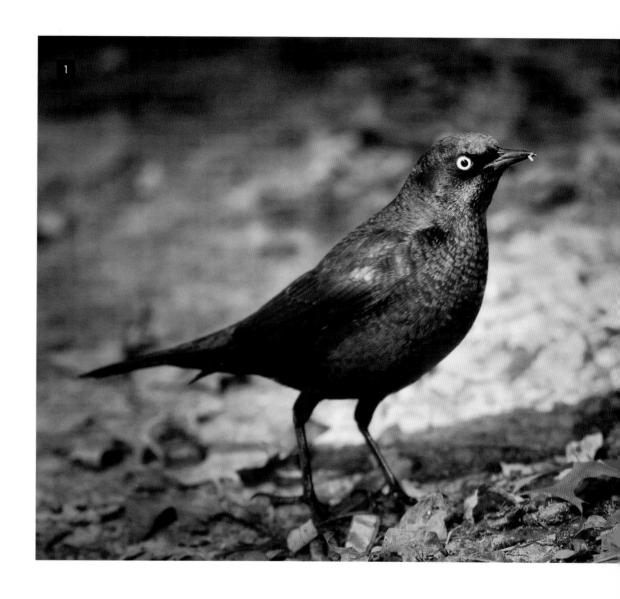

1

can drink brackish water that would kill other species. This Mourning
Dove sitting in the snow was photographed in Central Park.

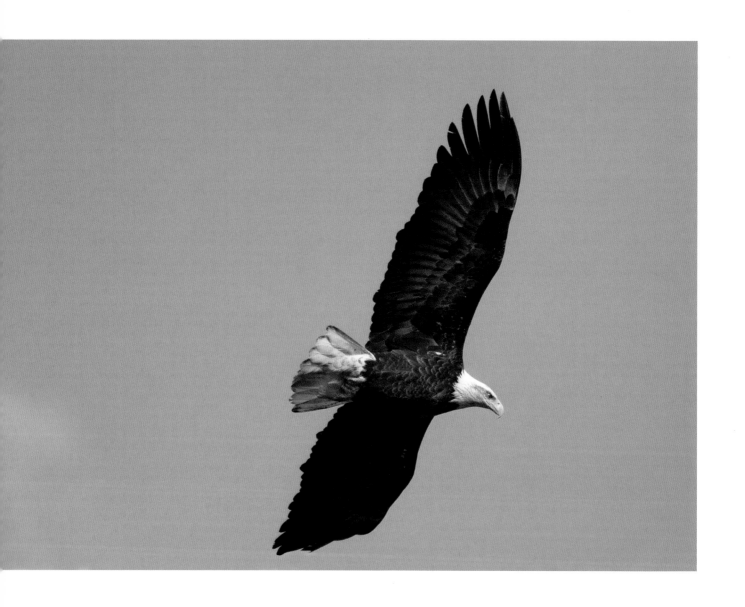

Bald Eagle

Bald Eagles are not actually bald, and their name derives from an older meaning of the word. Our nation's symbol since 1782, the Bald Eagle has been a spiritual symbol for Native Americans long before that. In decline since the early twentieth century as a result of hunting and the use of DDT and other pesticides, both conservation efforts and the banning of DDT in the early 1970s has helped the population rebound. Once on the list of endangered species, the Bald Eagle made such a comeback that it was removed from the list in 2007. Eagle nests are the largest nests built by birds and can be found in many places in the tristate area. In 2015, Bald Eagles nested on the south shore of Staten Island, the first time the species has nested in New York City in more than 100 years. Young male Bald Eagles are brown overall and don't get their white "crowns" until they become sexually mature, usually in their fifth year. Mature male and females have the same coloration, although the male is slightly smaller than the female. Northern birds move south for the winter when rivers and lakes freeze, resulting in a large influx of Bald Eagles along the Hudson. This is the only Bald Eagle I have ever seen in any New York City park. This shot was taken as the bird flew east to west over the Harlem Meer.

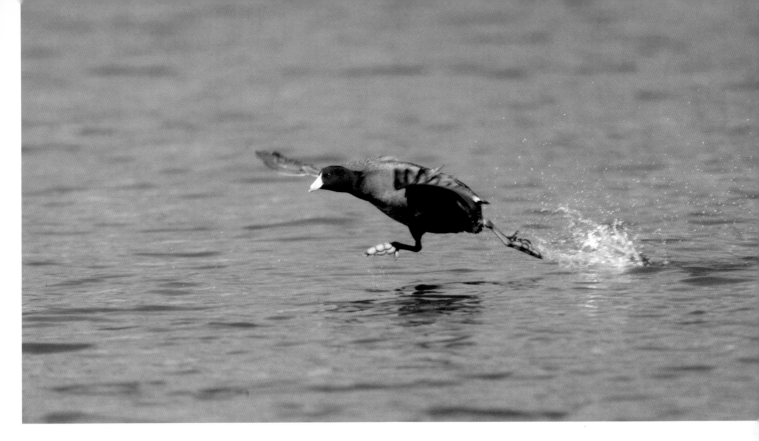

American Coot

Although the American Coot is often mistaken for a duck, it is a distinct species much closer allied to rails than ducks. In this shot of an American Coot taking flight, the lobed toes of the bird are visible. Unlike ducks, coots have individual toes with thick lobes that allow them to walk over soft ground. Coots can only get airborne by running along the water until they pick up enough speed. American Coots are dark gray with plump, almost hen-like bodies (they are often referred to as "mud hens") and small heads with white beaks. They are year-round residents of the West Coast and Florida. Northern birds that nest in Canada and the Midwest migrate to the Caribbean, Mexico, and the southeastern United States. In winter, they are a common sight on waterways free of ice in the New York metro area.

Snowy Owl

Snowy Owls are large birds of the Arctic tundra, where their main food is lemmings. They are one of the few diurnal owls, and in the 24 hours of daylight in the Arctic summer, they hunt at all hours. They are the largest North American owl by weight. They like wide-open spaces. In our area, the best place to find them is in dune grass along beaches, where they doze during the day and hunt at night. At both their wintering and breeding grounds, they eat a wide variety of prey including small mammals, ducks, squirrels, and rabbits. Snowy Owls eat their entire prey and regurgitate the indigestible parts. Mature male Snowy Owls are almost pure white, while females are covered in dark spots—see the female in this photo. They are a common sight at Kennedy Airport, where wildlife biologists have been hired to trap and move Snowy Owls out of the area after a recent controversy involving the killing of the owls. This female Snowy Owl was photographed not far from Kennedy Airport, at Breezy Point.

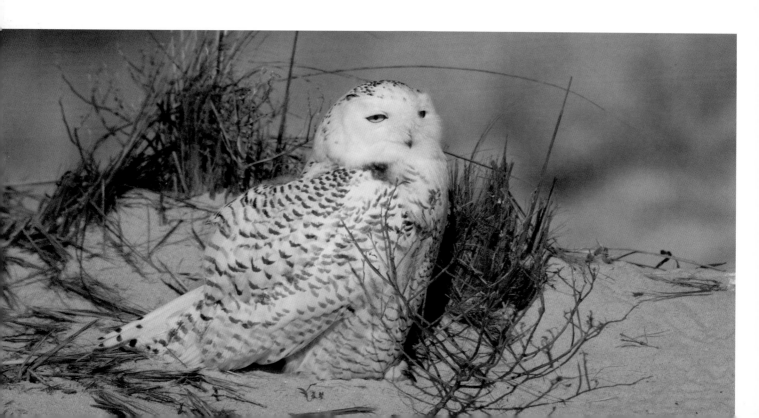

Cooper's Hawk

Cooper's Hawks are medium-size hawks that are common throughout the United States and southern Canada. Cooper's Hawks that breed in Canada migrate south for the winter, sometimes as far as Central America. The female is much larger than the male; both have red eyes and yellow talons, with white breasts streaked with brown "teardrops." Once a raptor of woodlands and open fields, Cooper's Hawks are moving into urban areas in increasing numbers, lured by a plentiful supply of pigeons, doves, and smaller birds. They are attracted to feeders, but not for the same reasons as smaller birds—hanging out near a feeder is a good way for the hawk to make a meal of the smaller seed-eating birds. The Cooper's Hawk in this photo is perched above a feeder in the Ramble in Central Park, looking for his next meal.

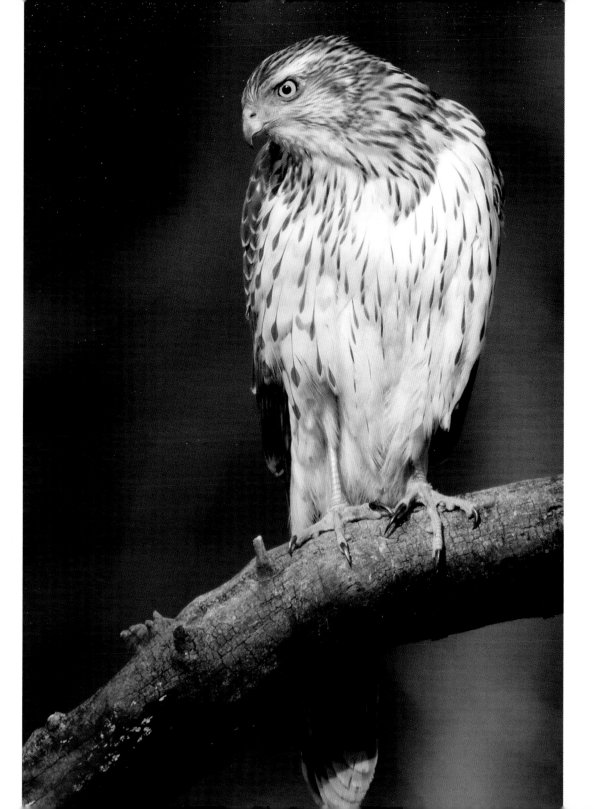

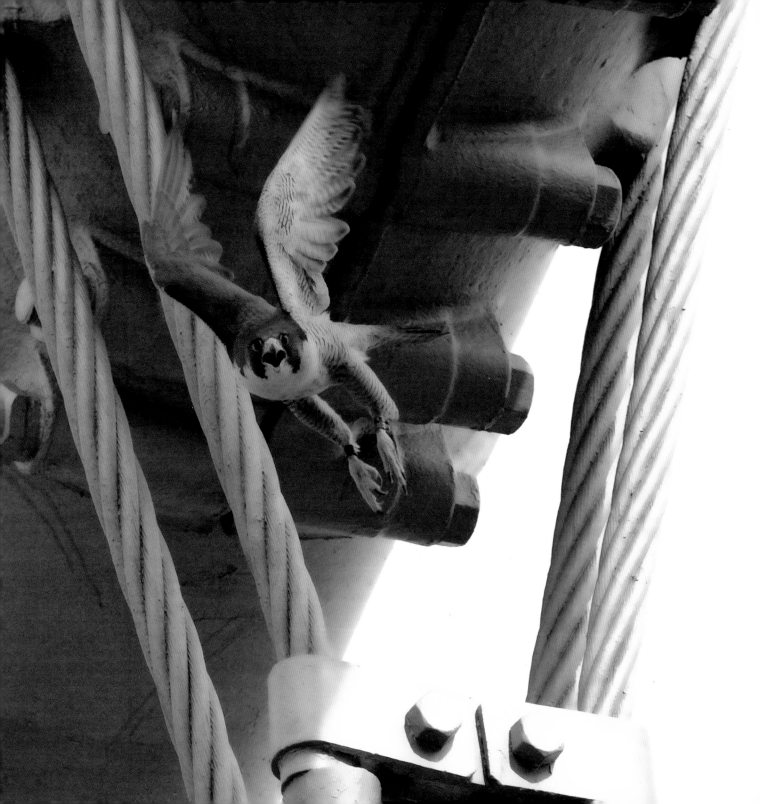

ACKNOWLEDGMENTS

Special thanks to my agent, Russell Galen, of Scovil Galen Ghosh Literary Agency, Inc., and my editor at The Countryman Press, Dan Crissman. Both have provided extraordinary assistance in bringing this book to print. Russ has long been a strong supporter of my photography, and Dan has provided invaluable professional advice and assistance in polishing my manuscript. I would also like to thank Malcolm Morris, birder extraordinaire, for his thoughtful comments and insights on my manuscript.

INDEX